# LINCOLN COUNTY
# *Revisited*

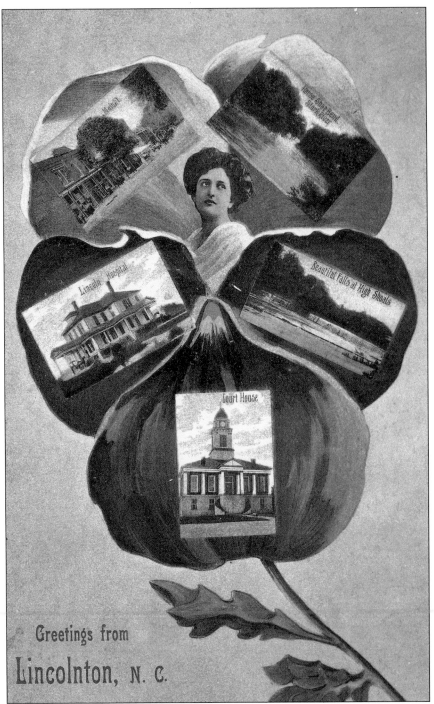

GREETINGS FROM LINCOLNTON. Placed upon the petals of a flower, surrounding the visage of a beautiful woman, are the sites in Lincolnton that greet visitors. Published during the first decade of the 20th century, this postcard features the Lincoln County Courthouse (1855–1921), East Main Street, Lincoln Hospital, "Beautiful Falls at High Shoals," and "Horse Shoe Bend." (Courtesy of Lincoln County Museum of History.)

IMAGES
*of America*

# LINCOLN COUNTY
## *Revisited*

Jason L. Harpe
Lincoln County Historical Association

ARCADIA
PUBLISHING

Published by Arcadia Publishing
Charleston, South Carolina

Printed in the United States of America

Library of Congress Catalog Card Number: 2003111347

For all general information contact Arcadia Publishing at:
Telephone 843-853-2070
Fax 843-853-0044
E-mail sales@arcadiapublishing.com
For customer service and orders:
Toll-Free 1-888-313-2665

Visit us on the Internet at www.arcadiapublishing.com

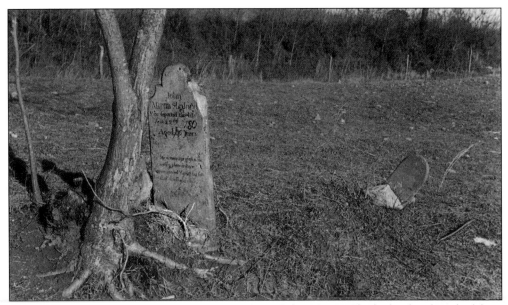

**JOHN MARTIN SHUFORD MONUMENT, LINCOLNTON.** John Martin Shuford, a loyalist, died from wounds received at the Battle of Ramsour's Mill, fought June 20, 1780. His grave is located at the edge of this local battlefield. In 1997 this tract of land was purchased by the Lincoln County Historic Properties Commission. The son of Johannes Schuffert (John Shuford Sr.) and Mary Clare Conrad, John Martin Shuford was born 1744 in Berks County, Pennsylvania. He married Eve Catherine Warlick, daughter of Johann Daniel Warlick, and Maria Barbara Schindler. They lived and farmed along the South Fork River, now Catawba County. The Lincoln County Historical Association paid to have a new monument erected in J.M. Shuford's honor, which was dedicated on June 22, 1997. The monument in the photo is now part of the permanent collection of the Lincoln County Museum of History. (Courtesy of Lincoln County Museum of History.)

# CONTENTS

# ACKNOWLEDGMENTS

As the second edition from the *Images of America* series, *Lincoln County Revisited* serves to complement Lincoln County's first volume, published in 2000. Setting out to compile and write a second photographic retrospective has proven quite difficult with the growth of the Lincoln County Historical Association over the past two years. This growth has come in the form of continuous book projects, newsletters, exhibits, research, assessments through the American Association of Museum's Museum Assessment Program (MAP), and the search for a new building to house the Association and Lincoln County Museum of History. A special debt of gratitude is due to the staff at Arcadia Publishing, particularly Maggie Tiller and Laura Daniels New, for their patience, professionalism, persistence, and unwavering commitment to the project.

Extra special thanks to Bill Beam for running all over the county with me to collect photographs and conduct research. This is one of the reasons why he received the Governor's Award for Volunteerism in 2003 for Lincoln County. Special thanks are also extended to Edward Little, Ann Dellinger, Sheldon Anderson, Beverly Cunningham, Robert Hamilton, Helen Peeler, Brad Guth, and Dan Barefoot for helping me with captions during the final hour. Without the help of these folks, this work would not have been accomplished.

Because the Historical Association's collection has grown by leaps and bounds since the release of the first book, this volume contains numerous newly acquired photographs. Many thanks are extended to the late Margretta Seagle for her foresight in labeling around 90 percent of the photographs in her collection and keeping them in order. The museum is fortunate to have had her collection, donated in 2002 by Mr. and Mrs. David Seagle of Charlotte, North Carolina. Other individuals who have made donations of photographs since 2000 include the following: the family of the late Nancy Claytor, Bill Stephen, Rev. Rudolph Roell, Jack L. Dellinger, Helen Peeler, Margaret Houser Carlen, Mary Sumner, David G. Thompson, Madge Philbeck, Bill C. Beam, and the late Hon. Harlan E. Boyles.

Those who graciously loaned images and material to this publication include Mary Long Abernathy, American Legion Post No. 30 (Lincolnton), Nancy Anthony, Susan Anthony, Alice Baker, Bill C. Beam, Inez Reep Beam, Regina Beam, Leonard and Barbara Blanton, Corinne Boyles, Polly Boggs Bryant, Louise Warlick Carlton, Cedar Grove Lutheran Church Archives, Caroline Clark Morrison, Milton and Mary Crowell, Robert and Ann M. Dellinger, Jack L. Dellinger, Paul M. Dellinger, Shelley Roper Early, Elizabeth Mauney Esterson, Buddy Funderburk, John and Betty Gamble, Odell S. Hager, Frances K. Hampton, Dr. James L. Haney, Mack Harvey, David C. Heavner, Nancy Hollingsworth, B. Lee Howard, Herman Howard, Tom Howard, Dot Johnson, Harvey and Celeste Jonas, Loretta Justice, Larry and Diane Leatherman, Carolyn Roper Lee, Ruth W. Leonard, *Lincoln Times-News*, Cheryl Lineberger, Edward Little, Edith Lomax, Barry Long, Edgar Love III, Sallie Duckworth Luckey, Peggy Moore, Sallie Nixon, Helen Peeler, Barbara Pickens, Sue M. Ramseur, Louise Reynolds, Jerry and Judy Robinson, Betty Gabriel Ross, Randolph Shives, Ed Smith, Margaret Viso, Mary Ethel Ward, Ronnie Ward, Don Wise, Sarah Yoder, and Charles Zug.

I also appreciate the help and cooperation of Robert Hamilton, Leonard Holloway, Leroy Magness, Dale Punch, David Clark, and Caroline Clark Morrison in supplying information for the book's text.

# INTRODUCTION

Lincoln County has a long history of contributing to the state and nation with fine statesmen, valiant soldiers, public servants, humanitarians, and spectacular athletes. Among these are people born and raised in Lincolnton and Lincoln County who, for more than 200 years, have made their livings, raised their families, worshiped in churches of all denominations, and done their part to make Lincoln County what it is today. The Lincoln County of today is a thriving county in the Piedmont region of North Carolina.

To revisit Lincoln County is to take a journey back to the time of log homes, one-room schools, economic depression, social upheaval, family reunions, financial growth, and social and cultural development. In the pages of this book, the role that family, religion, and culture have played in shaping the lives of the citizens from Denver to Cat Square can be seen. As the county moves, decade by decade, through the 21st century, the virtues, values, and foundations sustained by the early settlers will continue to build for future generations.

It is appropriate, and certainly necessary, to revisit the place that we now call home. Not only do we revisit the place to pay tribute to those who left the original footprints in the sand, but to discern what makes the area unique. In examining Lincoln County's uniqueness, we find that many towns of similar size share the same experiences, trials, tribulations, hardships, and accomplishments. For we know with certainty, that history is made up of both good times and bad times. It is in the good times that we celebrate and reminisce and through adversity we build character and strength.

We undertook this book project with no intention of replacing any earlier publication on Lincoln County's past. This book does not serve as a definitive history of the county, but rather adds to the current store of knowledge of the county's history and shed light on those people and places that define who we are. The photographs included in this book come from all over the county. They make their homes in shoeboxes, attics, cedar chests, and scrapbooks—some with torn edges, other with water stains, faded corners, and names written in pencil and pen on the back. The images range from the daguerreotypes of the mid-19th century to the 35 mm Kodak film of the present. Reunions, birthdays, streetscapes, period clothing and cars, school groups, industry, and church groups can all be seen in these images.

This books represents the Lincoln County Historical Association's commitment to its mission of collecting the artifacts of our heritage in Lincoln County and presenting it, not only to its citizens but to people all over the United States, in a most vivid and candid fashion. Through photographs, we can step across a "bridge to the past." These photographs help us better understand what it was like to walk in downtown Lincolnton when the streets were dirt; how people celebrated the return of soldiers from the wars; the devastation of the Flood of 1916; how the architecture of homes has changed in 100 years; and the value placed on family over the years. Our hopes are that people will spend time thumbing through the pages of this book to find a relative, friend, or a former classmate or coworker. We also hope that this publication will impress upon people the need to preserve family and community photographs of all types from all periods. Without any record of the past, we have no model or source by which to gauge our course for the future.

We would like help from those who possess a genuine interest in assisting us in further researching the specifics of the people and places on display in the following pages.

Jason L. Harpe
September 2003

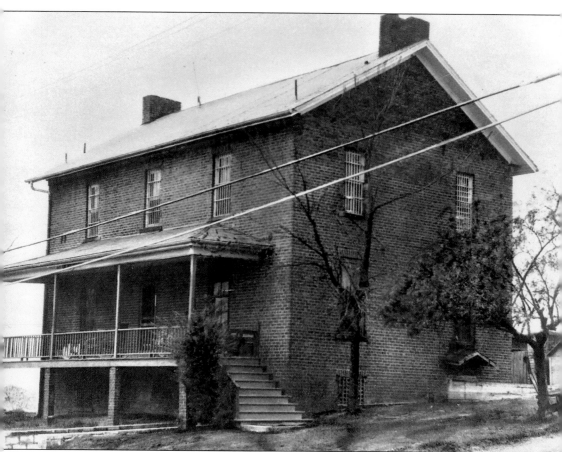

LINCOLN COUNTY JAIL, 1849–1956. As the population of the area increases, more jail space is needed. The old Lincoln County Jail, pictured above, served Lincoln County from 1849 until 1956. It was built on the site of the present jail, Lot Number 17, Southwest Square, and was purchased from Barbara Kerr for $130. Andrew J. Hause was paid $143 to tear down the old jail. All materials that could be salvaged from this jail, including the brick, were recycled into the new structure. Also constructed were a whipping post, a stable, a smokehouse, a corncrib, and an outhouse, all at total erection cost of $3,030. (Courtesy of Lincoln County Museum of History.)

# One

# *Heart of the County*

# LINCOLNTON

ATOP THE LINCOLN COUNTY
COURTHOUSE, LINCOLNTON.
Workers stand atop the dome
and weathervane of the Lincoln
County Courthouse in downtown
Lincolnton. The courthouse's
bricks have been painted with
a red wash. An impressive brick
structure, the courthouse in this
photograph was completed in
1855. Bricks for the building were
made on Clark's Creek at the
Ramsour's Mill battleground site.
Columns supporting the roof of the
porticos were made of brick then
covered with plaster. The plaster
workmanship on the columns,
pilasters, and first story exterior
walls gave the appearance of
stone. With a tower, lead-covered
dome painted yellow, four-faced
clock, and weathervane, this
courthouse was a local landmark.
It was demolished on May 12,
1921, and replaced by the present
Lincoln County Courthouse.
(Courtesy of Regina Beam.)

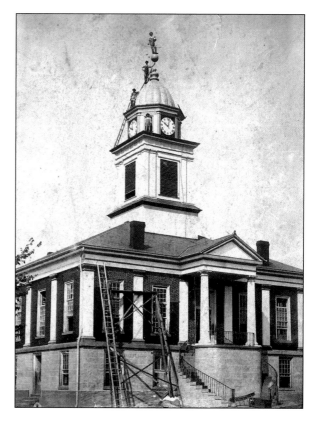

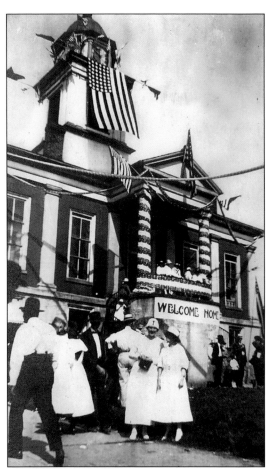

**WELCOME HOME DAY, WORLD WAR I, LINCOLN COUNTY COURTHOUSE.** The citizens of Lincoln County adorned the courthouse with patriotic flags, ribbons, and a large banner proclaiming "Welcome Home." Ladies of the Red Cross stand in front of the courthouse to celebrate the event. In the program souvenir titled *Welcome Home Day to Our War Heroes*, John M. and Paul J. Mullen state "Lincoln County's own will forever be synonymous with such names as Ypres, Voormezelle, The Hindenburg Line, Bellicourt and others." (Courtesy of Margaret Viso.)

**WELCOME HOME DAY IN DOWNTOWN LINCOLNTON.** From a window in one of the offices on the southside of East Main Street, a photographer captures the patriotism and excitement of "Welcome Home Day" on July 1, 1919. (Courtesy of Margaret Viso.)

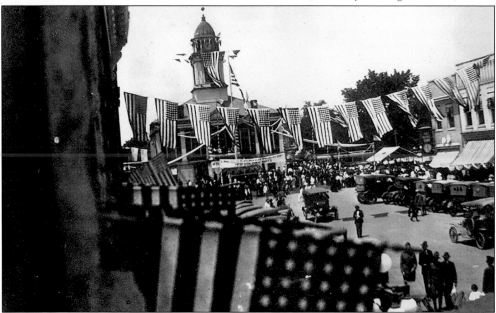

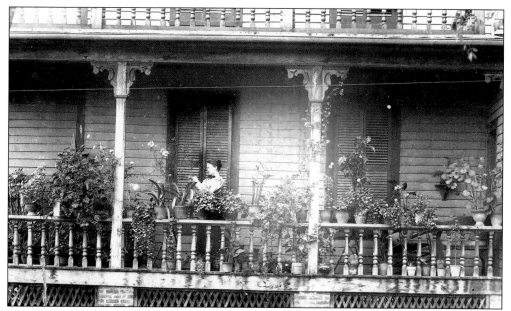

**MRS. W.S. BYNUM ON HER FLOWER PORCH.** Mrs. William Shipp (Mary L.) Bynum takes some time out of her busy schedule of watering and maintaining her flowers for this photograph taken in the 1890s on Main Street in Lincolnton. Mrs. Bynum adorned her beautiful Victorian porch, featuring decorative brackets and lattice work, with various plants. Mary Louisa Bynum was the daughter of Rev. Dr. Moses A. Curtis, rector of St. Luke's Episcopal in Lincolnton, and wife of Rev. William Shipp Bynum (1848–1898). (Courtesy of Lincoln County Museum of History.)

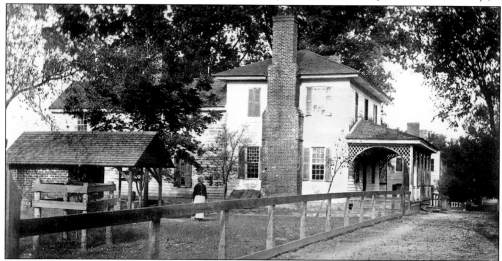

**DR. SAMUEL P. SIMPSON HOUSE, WEST MAIN STREET, LINCOLNTON.** Dr. Samuel P. Simpson was a practicing physician in Lincolnton during the early part of the 19th century and became principal of the Pleasant Retreat Academy in June 1825. Simpson was also a carriage-maker in Lincolnton. From Peter Summey, he purchased two lots in 1827, number eight (corner lot) and number nine in the Northwest Square of Lincolnton. Summey built the house between 1817 and 1827. Simpson's wife was Susannah Barbara Wilfong, daughter of John Wilfong. The house was torn down in the 1970s, and the Lincoln County Public Library (306 West Main Street) was built on the site. (Courtesy of Lincoln County Museum of History.)

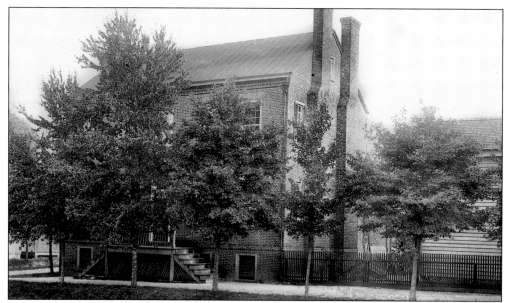

"SHADOWLAWN," LINCOLNTON. This beautiful, early 19th century, brick residence stands on West Main in downtown Lincolnton and is listed on National Register of Historic Places. Built by Paul Kistler, a Lincolnton businessman, Shadowlawn has gutter boxes beneath the cornice of the front façade that read the year 1826, the date of construction. After his father's death, Kistler's son Lawson sold the house to Augustus Pinkney James in 1871. A.P. James was a local cabinetmaker. His son, William Pinkney James, captured this image of the house around 1896. W.P. James was a cabinetmaker like his father, and was also a photographer, pianist, and painter. (Courtesy of Lincoln County Museum of History.)

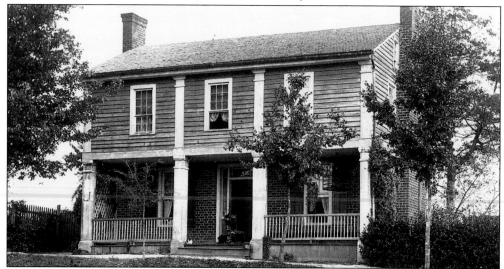

HOUSER-HILDERBRAND-BURGIN HOUSE, WEST MAIN STREET, LINCOLNTON. In 1840, Peter Houser III built this beautiful half-brick, half-frame house on West Main Street in Lincolnton. It is the only known structure with this style of construction in Lincoln County. Houser sold the house to Dr. Samuel P. Simpson in 1841, and Dr. Simpson sold the property to Isaac Houser, Peter's brother, in 1842. William P. James took this photograph during the 1890s. (Courtesy of Lincoln County Museum of History.)

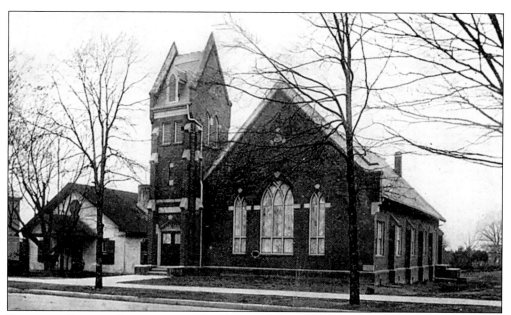

REFORMED CHURCH, LINCOLNTON. The first two decades of the 20th century saw the building of some of Lincoln County's finest, largest, and most articulated churches. Emanuel Reformed Church was built in the Gothic Revival style on the third block of East Main Street in 1913. The church was designed by the Wilmington architect Henry E. Bonitz. The Reformed congregation was organized in 1910, after the former house of worship (Old White Church) burned in 1893. (Courtesy of Lincoln County Museum of History.)

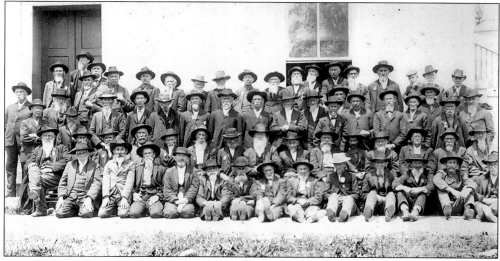

OLD SOLDIERS REUNION. Assembled on the south side of the Lincoln County Courthouse are the valiant soldiers of Lincoln County who fought during the Civil War. During the 1890s in Lincoln County, these soldiers formed the United Confederate Veterans to celebrate the war efforts of Lincoln County, North Carolina, and across the South. On April 20, 1865, before many of Lincoln County's soldiers returned from war, Gen. John C. Palmer's Federal Cavalry Brigade marched into Lincolnton. General Palmer lodged at the home of Col. John F. Phifer on West Main Street and visited the Lincoln Lodge No. 137, Ancient Free and Accepted Masons, (A.F. & A. M.) (Courtesy of Leonard and Barbara Blanton.)

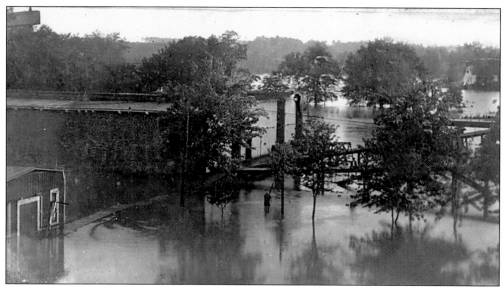

**DANIELS COTTON MILL, 1916 FLOOD, LINCOLNTON.** The flood of the century occurred in July 1916. The rain started falling around 4 p.m. on Friday, July 14. It poured for 28 hours. The heaviest rain, however, occurred on the eastern slopes of the mountains around the headwaters of both the South Fork and Catawba Rivers. On Sunday and Monday (July 16 and 17), both rivers were described as "ragging torrents." For local residents, the water was from hill to hill. The peak of the flood occurred on Sunday night. The mill shown in the photograph above is assumed to be Daniels Cotton Mill. (Courtesy of Jack L. Dellinger.)

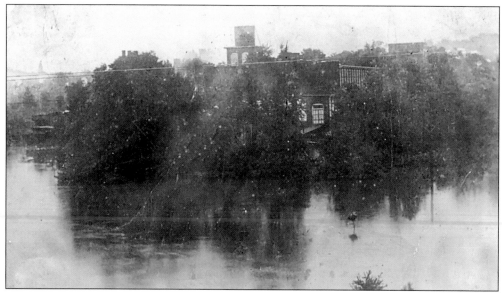

**DANIELS COTTON MILL, 1916 FLOOD, LINCOLNTON.** Every bridge and trestle on the South Fork and Catawba Rivers was destroyed during the Flood of 1916. Roads and railroads were washed out. Homes, businesses, and even cotton mills were swept away. Crops were destroyed. More than 50 people lost their lives. Travel and communication was disrupted for months. Money losses ran into the millions. The Daniel Cotton Mill is barely visible above the trees and flood. (Courtesy of Jack L. Dellinger.)

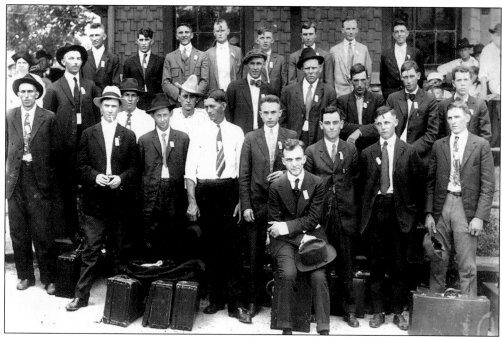

**REGISTRANTS IN 1917, WORLD WAR I, LINCOLNTON.** On August 5, 1918, and large group of Lincoln County men wait with the luggage to depart for Camp Wadsworth, Spartanburg, South Carolina. The men are identified as Livy Anthony Huskin, Joseph Baxter Cherry, Julius Martin Barnes, McDowell Perkins, Robert Burgin Hauss, Junius Leroy Rhyne, Dennis Edney Hoover, Norcum A. Blackburn, Carl L. Schrum, Robert Carl Hoover, George Sol Sain, Henry Early Carpenter, Jame Foy Saunders, Dorus Leonhardt, Alvin Z. Canipe, Press Bynum, Jacob Wyatt McNairy, Lee Arrison Burgess, Forrest V. Friday, Marvin Clarence Hoover, and Clarence Tillman. (Courtesy of American Legion Post No. 30, Lincolnton.)

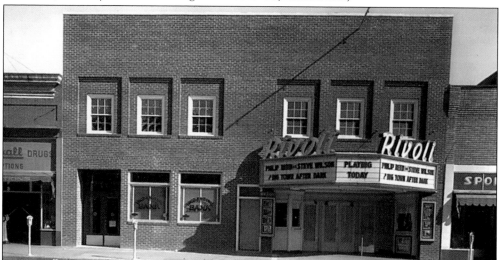

**RIVOLI THEATRE, EAST MAIN STREET, LINCOLNTON.** Many lucky Lincoln County citizens remember movies at the Rivoli in downtown Lincolnton. The Rivoli was located on the north side of the first block of East Main Street. The building is now occupied by Rusty and Company Salon. (Courtesy of Lincoln County Museum of History.)

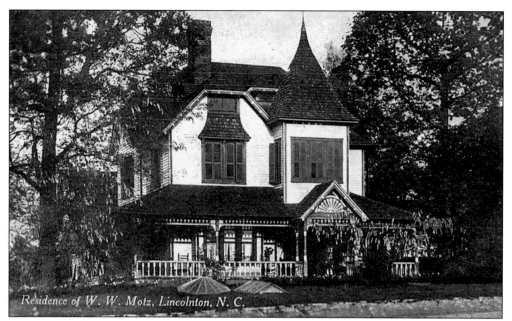

*Residence of W. W. Motz, Lincolnton, N. C.*

**W.W. MOTZ RESIDENCE, LINCOLNTON.** The craftsmanship found in the architecture of the W.W. Motz residence can be attributed to the Motz's meticulousness and experience as a builder and contractor in Lincolnton. William Wilson Motz was the son of Caleb Motz and Emmaline Almira Carson. Caleb Motz was an influential and prominent citizen in Lincoln County, who was known as a progressive farmer and politician during the 19th century. The house was altered in the 20th century and is currently the home of Mr. and Mrs. Charles Eurey, 1010 South Aspen Street. (Courtesy of Lincoln County Museum of History.)

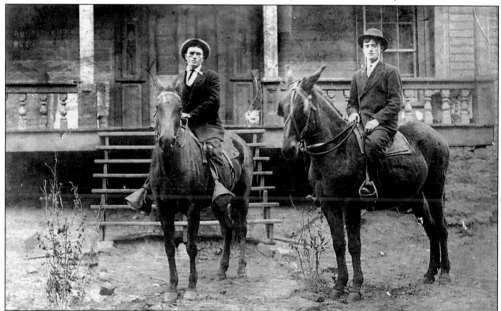

**HENRY AND R.A. DELLINGER, LINCOLNTON.** In this photograph, taken about 1914–1915, Henry Dellinger, left, and R.A. Dellinger sit atop their horses in front of Henry's home on South Cedar Street in Lincolnton. Henry died in the house in July 1932. (Courtesy of Jack L. Dellinger.)

**DAVID POLYCARP RHODES HOUSE, LINCOLNTON.** David Polycarp Rhodes built his residence on the southern edge of Lincolnton, near the Massapoag Mill, in 1906. The prominence and affluence of the Rhodes family is manifest in the house's mixture of Queen Anne and Colonial Revival architectural styles. D.P. and his father John M. Rhodes operated the Massapoag Mill, then known as the Rhodes Manufacturing Company. (Courtesy of John and Betty Gamble.)

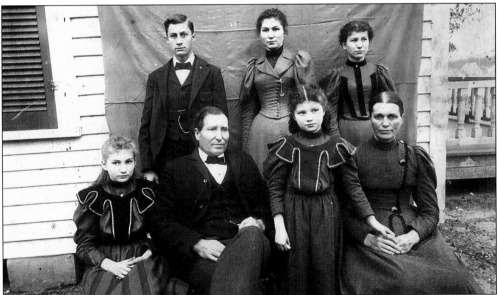

**JOHN M. RHODES FAMILY.** The John M. and Margaret Aderholdt Rhodes family draped a cloth over the clapboards of their home for this photograph in 1897. John Melancthon Rhodes (1849–1921) served as the register of deeds (1874–1882) in Gaston County and was a lucrative businessman in the textile industry. The children of John M. and Margaret Rhodes are David Polcarp, Lillie May, Violet Almetta, Mabel Rosalie, Georgia Agnes, Ada (not pictured), and C. Junius. (Courtesy of John and Betty Gamble.)

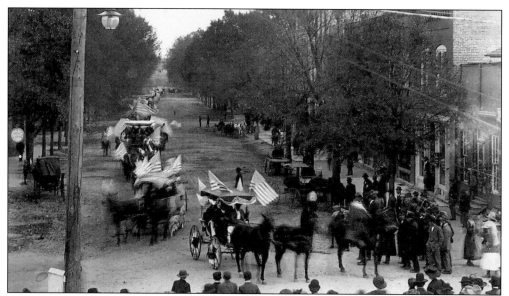

**July 4th Parade.** A July 4th parade in downtown Lincolnton moves up East Main Street and turns the corner to go around the courthouse. Many changes have taken place on this, the main business block since Lincolnton's earlier days. (Courtesy of Lincoln County Museum of History.)

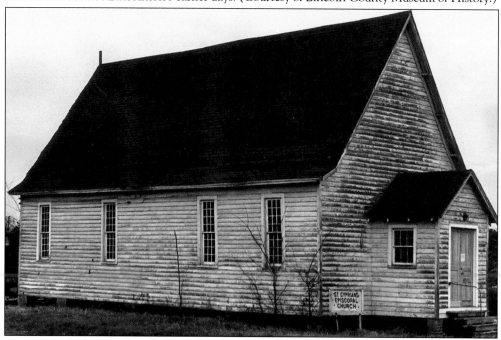

**St. Cyprians Episcopal Church, Lincolnton.** Rev. William R. Wetmore, rector of St. Luke's Episcopal Church in Lincolnton, helped organize two churches and one Sunday school class for African-Americans from 1862 to the 1880s. A black Sunday school class was organized at St. Luke's Episcopal Church in 1862, and St. Stephens Mission's chapel was built in 1872. St. Cyprians Episcopal Church was established in 1886. The church once stood on West Church in Lincolnton. The property consisted of a church, a parsonage, and a building used as a school. The church was torn down during the 1970s. (Courtesy of Lincoln County Museum of History.)

**C. WILLIAM RHODES HOUSE, SOUTH ASPEN ST., LINCOLNTON.** Members of the Rhodes family stand outside their home on South Aspen Street for this photograph taken during the 1910s. Built around 1907, the Rhodes house showcases a large wraparound porch supported by turned posts and sawnwork brackets. Christian William Rhodes moved to Lincolnton earlier in the 20th century with his brother John M. Rhodes and his nephew David P. Rhodes to establish the Rhodes Manufacturing Company. The property remained in the Rhodes family until 1948. (Courtesy of Lincoln County Museum of History.)

**INTERIOR OF FIRST NATIONAL BANK, LINCOLNTON.** First National Bank of Lincolnton was established in 1903 on the northeast corner of East Main Street in downtown Lincolnton. Following the 1929 stock market crash 1929, the bank moved to the former County National Bank building, across the street on the southeast corner of the East Main Street. Business continued at this location until the structure was demolished in 1976 and replaced by the current building. With several mergers, the name changed to Carolinas First National, NCNB, NationsBank, and Bank of America. (Courtesy of Lincoln County Museum of History.)

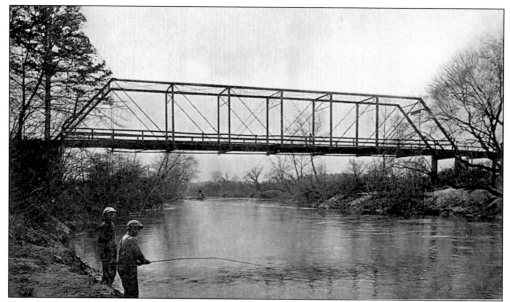

**SOUTH FORK RIVER AND BRIDGE, LINCOLNTON.** As the 20th century rolled in, three steel structures bridged the South Fork of the Catawba River, each allowing citizens of Lincolnton to reach different parts of the area. Pictured above is the West Main Street Bridge, the middle bridge, and was reached by proceeding on West Main Street and crossing the river behind the current Winn-Dixie. Traveling this route, people could reach the sections of Howard's Creek, Bethpage Church, and, further west out of the county, Fallston. This bridge was replaced by the current bridge in 1950. (Courtesy of Lincoln County Museum of History.)

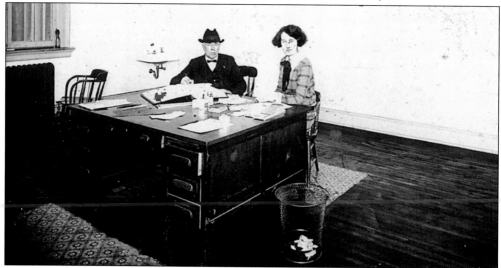

**JOHN EDNEY HOOVER AT COURTHOUSE.** John Edney Hoover (1863–1931) is pictured here with Nina Nixon, daughter of Alfred Nixon, in the register of deeds office at the Lincoln County Courthouse. He was the son of Edney (1837–1908) and Mary Catherine Dellinger Hoover (1841–1929). Under the urging of his father-in-law, Rev. Coatesworth Lee Gingles Wilson, John developed an interest in politics and joined the Democratic Party. He was elected as the Democratic representative from Lincoln County in the North Carolina House of Representatives and served as register of deeds from 1920 to 1926. (Courtesy of Helen Peeler.)

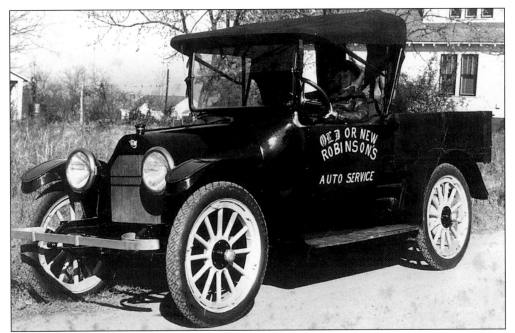

**OLD OR NEW ROBINSON'S AUTO SERVICE.** In 1947 Jesse Robinson opened a business on East Main Street in a building that stood between what is today Clark Tire Company and the Lincolnton Police Station. The first project that Mr. Robinson and his mechanics took on was the restoration of this 1914 REO Truck. Robinson and his mechanics reworked the truck and used it as an advertising tool for their auto service through the remaining portion of the 1940s. (Courtesy of Jerry and Judy Robinson.)

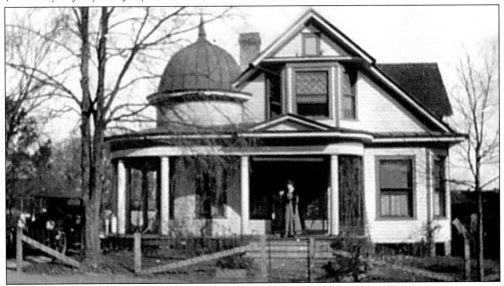

**JOHN R. MOORE HOUSE, SOUTH CEDAR STREET, LINCOLNTON.** During 1911, at the time this photograph was taken, Milton Ensor, his wife, Lillie, and their two daughters, Naomi and Ruth, lived in the Moore house. Named for railroad depot agent John R. Moore, who built the house around 1909, the house has an eclectic mixture of Queen Anne, Colonial Revival, and Craftsman Bunglow–style architectural features. (Courtesy of Milton and Mary Crowell.)

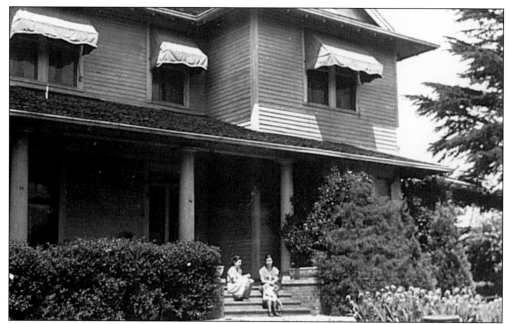

S. HOPKINS HOUSE, PINE STREET, LINCOLNTON. The Milton Ensor family occupied the Hopkins House during 1939 and 1940. Ensor was the manager of the Hopkins estate. When this photograph was taken, the Ensor family included Milton Ensor, his wife Lillian, their daughter Naomi, her husband Grady Crowell, and Naomi and Grady's children Lillian and Milton. The family also included daughter Ruth, her husband Lake Hobbs, and their son Charles. (Courtesy of Milton and Mary Crowell.)

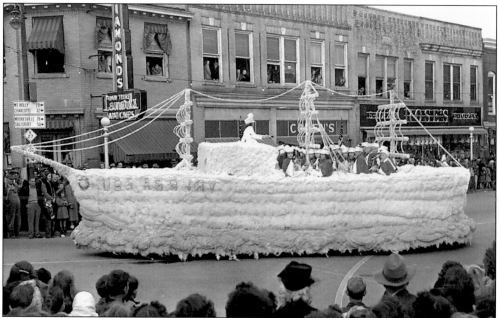

ASBURY SCHOOL PARADE FLOAT, LINCOLNTON, 1948. Asbury School's large float heads up East Main Street for a parade in 1948. The float took the first place prize of $20. (Courtesy of Lincoln County Museum of History.)

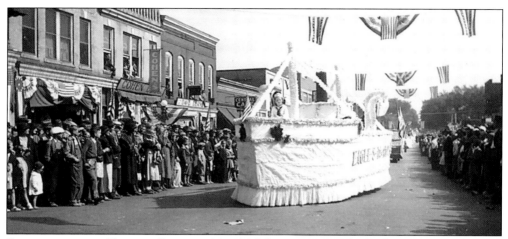

SESQUICENTENNIAL PARADE, OCTOBER 10, 1935, LINCOLNTON. The Eagle Dime Store float cut through a large crowd in downtown Lincolnton during the Sesquicentennial parade on October 10, 1935. Lincolnton's 150th anniversary celebration drew people from neighboring counties for what was called the "biggest crowd in Lincoln history." A reported 25,000 people heard a "forceful and effective" address from North Carolina governor J.C.B. Ehringhaus on the steps of First Methodist Church in downtown Lincolnton. The crowd also saw a circus, carnival, street parade, Native American dances, historical pageant, fireworks display, football game between Lincolnton High School and Lexington High School, and a grand ball at Lincoln Lithia Inn. (Courtesy of Lincoln County Museum of History.)

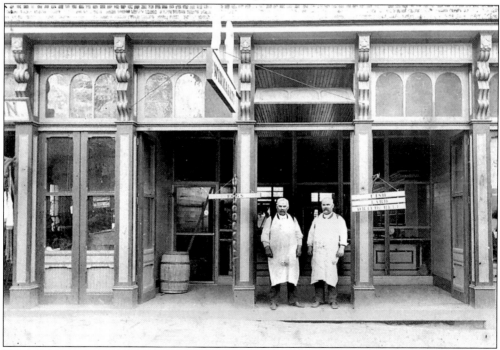

TWIN MARKET MALLARD BROTHERS, LINCOLNTON. The Twin Market on Main Street in Lincolnton was operated by the Mallard brothers during the early 20th century. John Mallard, one of the twins, was the business's proprietor. The Twin Market sold choice fresh meats and high grade sausage. (Courtesy of Regina Beam.)

# ARMISTICE DAY CARNIVAL

## LINCOLNTON, NORTH CAROLINA

"That Pleasant City in the Land of Mineral Springs"

## FRIDAY, NOVEMBER 11TH--9 YEARS AFTER

### DAWN TO MIDNIGHT

IN COMMEMORATION OF THOSE BRAVE AND PATRIOTIC SONS
AND DAUGHTERS OF LINCOLN, WHO FREELY
GAVE THEIR SERVICES
1917 to 1918—1898—1861 to 1865

### SPONSORED BY:

| | |
|---|---|
| Lincolnton Kiwanis Club | The Merchants' Association |
| David Milo Wright Post, American Legion, and Auxiliary | |
| The Woman's Club | City of Lincolnton |
| Troop "E," 109th Cavalry | |

Special Rates on All Railroads and Bus Lines to and from Lincolnton for the Day

ARMISTICE DAY PROGRAM, ARMISTICE DAY CARNIVAL, NOVEMBER 11, 1927, LINCOLNTON. On Friday, November 11, 1927, the Armistice Day Carnival took place in Lincolnton. The event was sponsored by the Lincolnton Kiwanis Club, Merchants' Association, David Milo Wright Post, American Legion and Auxiliary, Women's Club, City of Lincolnton, and Troop "E" 109th Cavalry. The carnival began at 7:00 a.m. with whistles to herald the day and concluded with a dance at the Lincoln Lithia Inn ball room. Other events of the day included a military and float parade led by the Oasis Temple Shrine Drum and Bugle Corps, American Legion band concert, live rooster chase on the courtsquare, boxing match at Lincolnton High School, and football game between Lincolnton High School and Spencer High School. (Courtesy of Lincoln County Museum of History.)

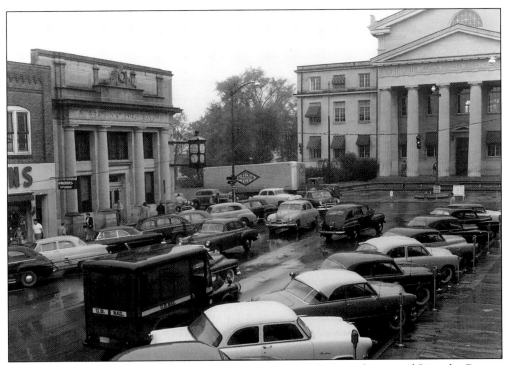

**THE 1950S IN DOWNTOWN LINCOLNTON.** During the 1950s, Lincolnton and Lincoln County saw an increase in population and boasted 58 manufacturing establishments (textiles, furniture, hosiery, and lumber), 2 hospitals (Gordon Crowell Hospital and Reeves Gamble Hospital), 18 churches (white and black), 2 railroads (Seaboard Airline and C&NW), 3 highways (US 321, NC 27, and 150), 2 newspapers, a radio station, 2 parks, 4 theatres, 2 hotels and motels, and 21 civic and cultural organizations. (Courtesy Lincoln County Museum of History.)

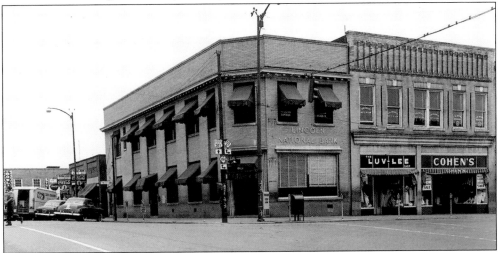

**NORTHEAST CORNER OF EAST MAIN STREET, LINCOLNTON, 1950S.** Lincoln National Bank, the Luv-Lee Shop, and Cohen's are open for business in this photograph from the 1950s of the northeast corner of East Main Street. Above the shops are W.H. Childs, Attorney at Law, and Jetton's Insurance. A bowling alley, billiards, and soda shop occupied the buildings further down the courtsquare, as seen in this photograph. (Courtesy Lincoln County Museum of History.)

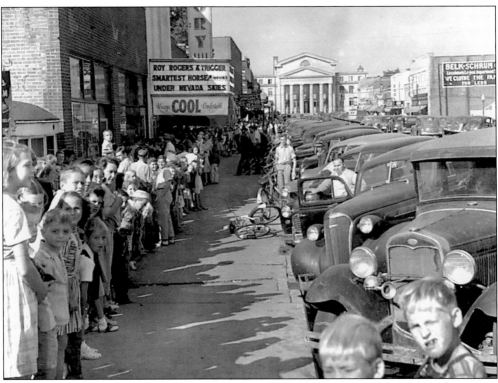

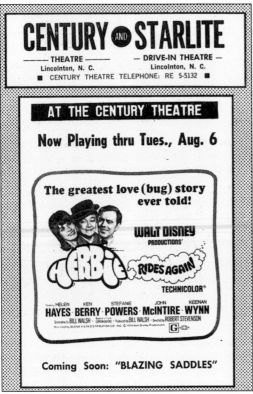

**CENTURY AND STARLITE**

THEATRE — — DRIVE-IN THEATRE —
Lincolnton, N. C.     Lincolnton, N. C.
■ CENTURY THEATRE TELEPHONE: RE 5-5132 ■

**AT THE CENTURY THEATRE**

**Now Playing thru Tues., Aug. 6**

The greatest love (bug) story ever told!

WALT DISNEY PRODUCTIONS'

HERBIE RIDES AGAIN

TECHNICOLOR®

Starring HELEN **HAYES** · KEN **BERRY** · STEFANIE **POWERS** · JOHN **McINTIRE** · KEENAN **WYNN**
Screenplay by BILL WALSH · Based on a story by GORDON BUFORD · Produced by BILL WALSH · Directed by ROBERT STEVENSON
Now released by BUENA VISTA DISTRIBUTION CO. INC. © 1974 Walt Disney Productions     **G**

**Coming Soon: "BLAZING SADDLES"**

CENTURY THEATER, EAST MAIN STREET, LINCOLNTON. Cars and people line the second block of East Main Street in front of the Century Theatre. The marquee advertised the feature show *Under Nevada Skies*, starring Roy Rogers and Trigger, "the smartest horse." In the 1940s, Ab Miller, owner of the Grand, located on the north side of East Main Street, closed the Grand and opened the Century across the street, with a fancy concession stand inside. Still, young couples courted in the balcony, there was a back alley door marked "Colored," and Pa could attend in his overalls. (Courtesy of Lincoln County Museum of History.)

CENTURY THEATER ADVERTISING CARD. The Century Theatre and Starlite Drive-In Theatre featured the well-remembered Walt Disney production of Herbie Rides Again on Tuesday, August 6 in Lincolnton. The Century Theatre used these advertising cards to draw attendance, in addition to advertising on their marquee. (Courtesy of Lincoln County Museum of History.)

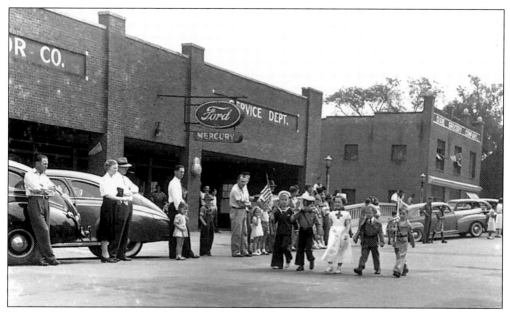

**KIDS ON PARADE.** Onlookers in front of Dixie Grocery Company and Ford Motor Company and Service Department watch as Johnny Cromer, the first child on the left, and Mary Alice Heavner, third from the left, march down East Main Street. During this parade in the 1950s, uniforms from various branches of the military were worn, and Mary Alice wore a uniform of the American Red Cross. (Courtesy of Lincoln County Museum of History.)

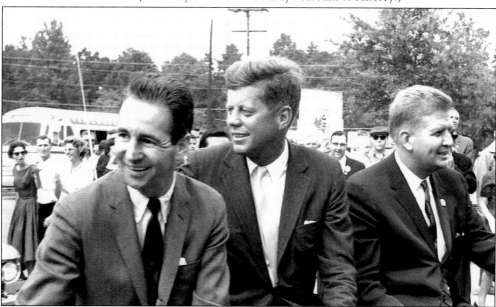

**PRESIDENT KENNEDY IN CHARLOTTE.** This photograph was taken in Charlotte in 1960 while all three men were campaigning for political office: David Clark for congress, representing Lincoln County; John F. Kennedy for President, and Terry Sanford for governor of North Carolina. David Clark had served Lincoln County from 1951 to 1957 as a member of the North Carolina General Assembly and again in 1963 in the state senate. (Courtesy of Caroline Clark Morrison.)

27

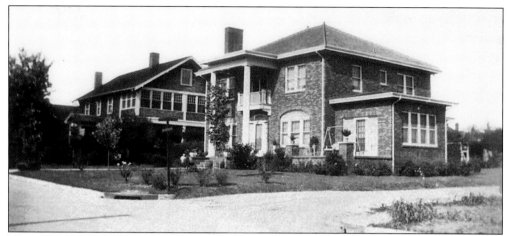

**WADE HAMPTON CHILDS HOUSE, LINCOLNTON.** The Wade Hampton Childs house is described in this photograph as a "typical residence" in Lincolnton. This two-story brick residence with a mixture of architectural styles was built by Wade H. Childs (1890–1974) on Laurel Street in 1928. "Hamp" was a first sergeant in the U.S. Army, where he spent four years as an army medic during World War II, seeing action in Europe. He later completed law school at Wake Forest University and joined his father in private practice in Lincolnton. In 1954, he was elected as solicitor of the old Lincoln County Recorder's Court. Gov. Dan Moore appointed Childs district solicitor in 1965. Childs won five consecutive terms as a democratic district attorney. He retired in 1984. (Courtesy Lincoln County Museum of History.)

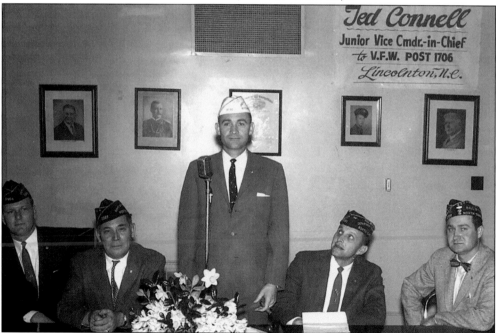

**TED MCCONNELL AT VFW IN LINCOLNTON.** Ted McConnell stands for this photograph during a visit to the Lincolnton VFW (Post 1706) during the 1950s. Hanging behind McConnell are photographs of some of Lincoln County's respected and honored war veterans, including Lt. William Ewen Shipp. Ted McConnell was the junior vice commander-in-chief. (Courtesy Lincoln County Museum of History.)

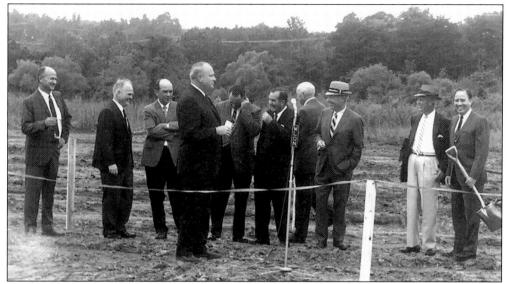

LINCOLN HOSPITAL GROUNDBREAKING. On Sunday, November 23, 1969, at 2:30 p.m., Lincoln County witnessed the dedication and open house of Lincoln County Hospital. Construction started in July 1967 and was completed in July 1969. During this time, James L. Sherwood was the hospital's administrator, and Mrs. Farrie W. Blackburn, R.N. was the director of nurses. Ralph L. Abernethy was the president of the board of trustees and Jack L. Thompson was vice-president. Other members of the board included Claude E. Davis, J. Everette Henley, Ralph C. Hull, Lester A. Mullen, James W. Warren, E. Blair Wilkinson Jr., John R. Gamble Jr., M.D., and Fred M. Houser. Members of the hospital's board of directors and county commissioners are shown in the photograph above at the groundbreaking. (Courtesy of John and Betty Gamble.)

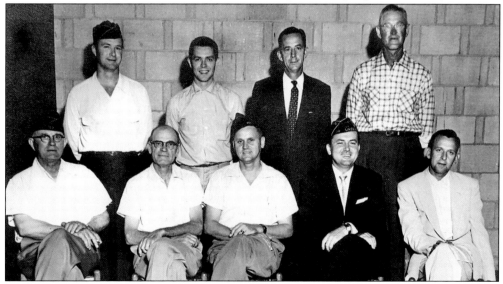

AMERICAN LEGION OFFICERS, 1955. The officers of the American Legion Post No. 30, Lincolnton, assembled for a photograph in 1955. The officers are identified, from left to right, as follows: (front row) Herman Beaman, Ernest Ballard, Cmdr. Ed House Sr., Stearn Warlick, and Jack Brown; (second row) Paul Gabriel, Bob Ramseur, John Crow, and T.E. Sain. (Courtesy of American Legion Post No. 30, Lincolnton.)

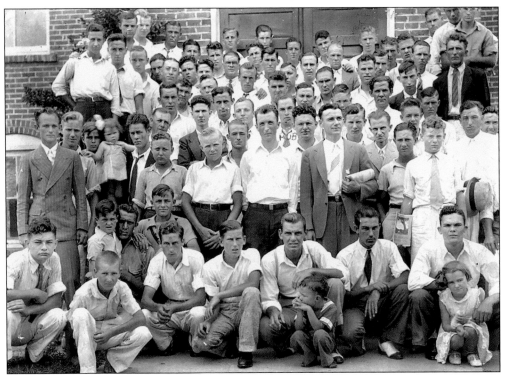

**LINCOLN AVENUE BAPTIST CHURCH SUNDAY SCHOOL GROUP.** Lincoln Avenue Baptist Church's Sunday School classes gathered together for this group photograph in front of the church around 1936. The church was organized on September 18, 1910, by several members of First Baptist Church and Riverview Baptist Church. In 1913 Daniel E. Rhyne sold the land on which the church now sits. (Courtesy of Jack L. Dellinger.)

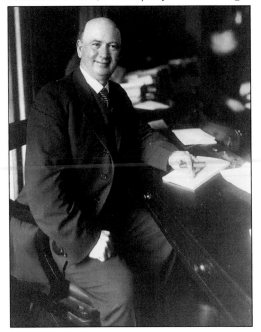

**EDGAR LOVE.** J. Edgar Love (1869–1920) attended the University of North Carolina at Chapel Hill and was a member of Beta Theta Phi. He was very active in the textile industry in Gaston and Lincoln Counties, organizing or managing such mills as Gaston Manufacturing Company, Daniel Manufacturing Company, Woodlawn Mills, Lincoln Mill, Avon Mill, Loray Mill, Burlington Mills, Saxony Spinning Mills, and Melville Mills. He also started E&R Love Dry Goods in Lincolnton and helped organize First National Bank of Lincolnton. He was a Lincolnton alderman (1903–1905), mayor (1907–1909), state legislator from Lincoln County (1915–1920), and chairman of the Lincoln County school board. He was also a member of the First Presbyterian Church in Lincolnton. (Courtesy of Edgar Love III.)

**North Carolina Sen. John Edwards and Al Dozier, Lincoln Times-News Editor.** *Lincoln Times-News* editor Al Dozier stops Sen. John Edwards for a short interview during Senator Edwards's stop in Lincolnton in 2003. Senator Edwards greeted a large group of supporters at the Lincoln Cultural Center and spoke briefly in the cultural center's reception hall. (Courtesy Bill C. Beam.)

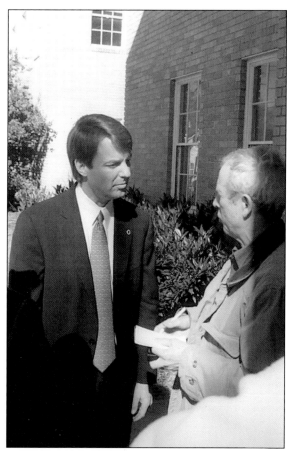

**County Commissioner Buddy Funderburk and Bob Dole.** Lincoln County Commissioner James "Buddy" Funderburk stands with Bob Dole on East Main Street in Lincolnton. Former U.S. Senator and Presidential candidate Bob Dole was campaigning for his wife Elizabeth Dole, who was running for the U.S. Senate. Elizabeth Dole also visited Lincolnton in 2003. (Courtesy of Buddy Funderburk.)

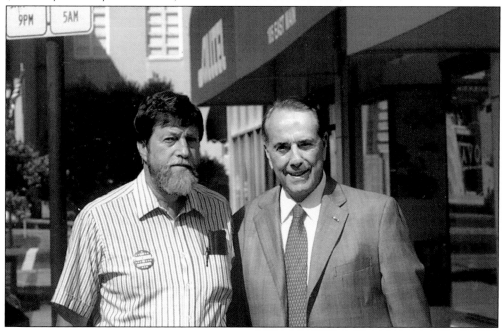

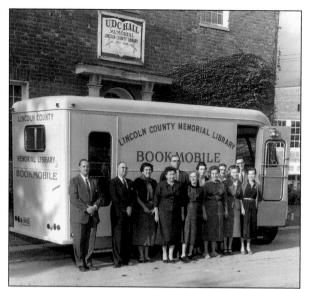

**LINCOLN COUNTY PUBLIC LIBRARY AND BOOK MOBILE, LINCOLNTON.** The county's earliest library was located at the Hoke house (later Inverness Hotel) in downtown Lincolnton. On May 5, 1925, the library was organized at the UDC Hall on Pine Street by local clubs in honor of Lincoln County soldiers. Miss Frances Fair was the first librarian. In 1948, the Lincolnton PTA established the Lincoln County Memorial Library's bookmobile as a service to the citizens of Lincoln County. The library moved to its current location on West Main Street in 1975. (Courtesy of Lincoln County Museum of History.)

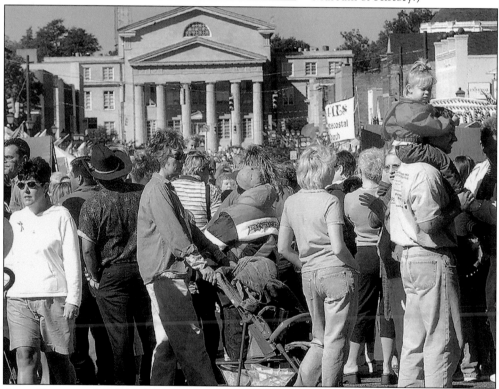

**APPLE FESTIVAL, 2002.** A large group crowds the first block of East Main Street in downtown Lincolnton for the county's Apple Festival. Lincoln County's first Apple Festival was held at Boger City United Methodist Church in September 1972. This celebration was the brainchild of Melinda Houser, Lincoln County home economics extension agent, who had experience with festivals in eastern North Carolina. With the assistance of Howard Waynick, agricultural extension agent, and local apple growers, Lincoln County began a festival that stills flourishes today. (Courtesy of *Lincoln Times-News*.)

*Two*

# FAMILY TIES

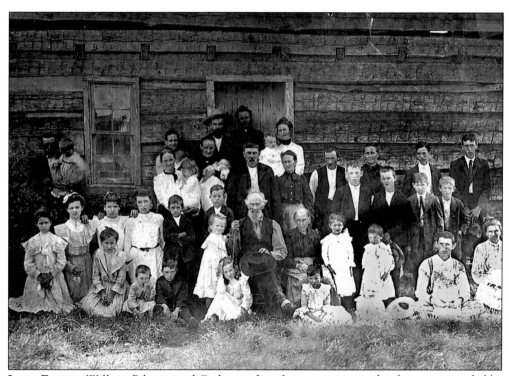

**LYNN FAMILY.** William Pilgram and Catherine Lutz Lynn rest in straight chairs, surrounded by their extended family for this photograph taken during the 1910s in front of their log home in western Lincoln County. (Courtesy of Helen Peeler.)

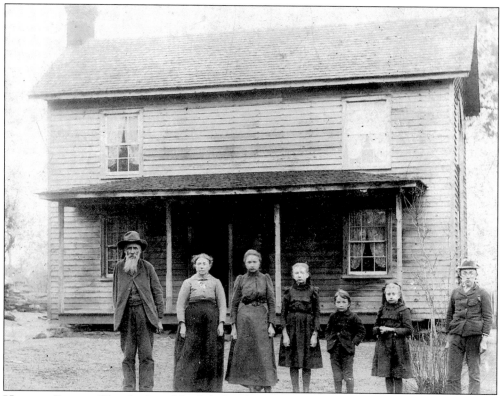

**HEEDICK FAMILY.** The Andrew Heedick family stands in front of their frame house for this family photograph taken during the late 19th century. Family members are identified, from left to right, as follows: Andrew Heedick, Minty Malvena Warlick Heedick, Bessie Heedick Rhodes, Minnie Heedick Smith, William Heedick, Ora Gertrude Heedick Smith, and Preston Heedick. (Courtesy of Cheryl Lineberger.)

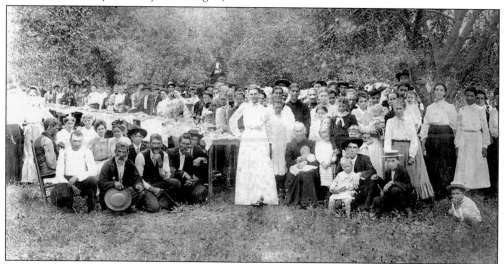

**SARAH BUFF SEAGLE BIRTHDAY AND FAMILY REUNION.** The Seagle family assembles around a long line of tables for the birthday celebration of Sarah Buff Seagle. She is pictured, seated, in a black dress in the center, holding Berton Smith. (Courtesy Inez Reep Beam.)

**YODER FAMILY.** Charles M. Yoder, a carpenter and farmer, poses with his father, Daniel A. Yoder, and children beside a tree stump for this photograph taken around 1919. The members of the Yoder family are identified, from left to right, as follows: Edith Pearl Yoder LeSueur (born March 10, 1898, and married John A. LeSueur), Lois Yoder Costner (born January 16, 1895, and married B.W.H. Costner), Daniel Alexander Yoder (October 5, 1834–January 6, 1927), Charles Maxwell Yoder (September 17, 1871–September 19, 1940), and Morris Samuel Yoder (born April 23, 1896, and married Laura Ruth Scronce). (Courtesy of Lincoln County Museum of History.)

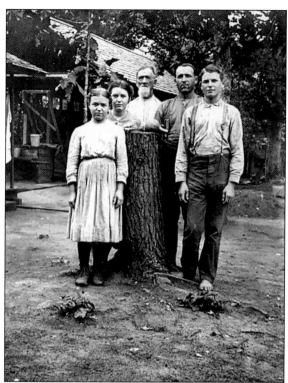

**J.M. REINHARDT FAMILY.** The J.M. Reinhardt family poses for this 19th-century photograph. Leila Rendleman Reinhardt stands above her husband and two daughters. The members of the family are identified, from left to right, as follows: Helen Reinhardt, Leila Rendleman Reinhardt, J.M. Reinhardt, and Elizabeth Reinhardt. (Courtesy of Edgar Love III.)

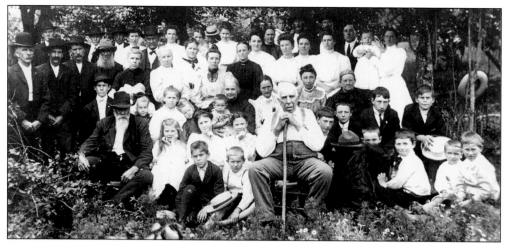

**JOHN SHRUM BIRTHDAY, JUNE 1907.** The family and friends of John Shrum (June 16, 1826–March 27, 1911) gather at his home on Union Church Road in Lincoln County for this photograph in June 1907. The gathering is to celebrate Shrum's birthday. John Shrum was the son of Solomon and Mary "Polly" Shrum and the grandson of pioneer Nicholas Shrum. John Shrum married Margaret Fox on October 14, 1851. (Courtesy of Leonard and Barbara Blanton.)

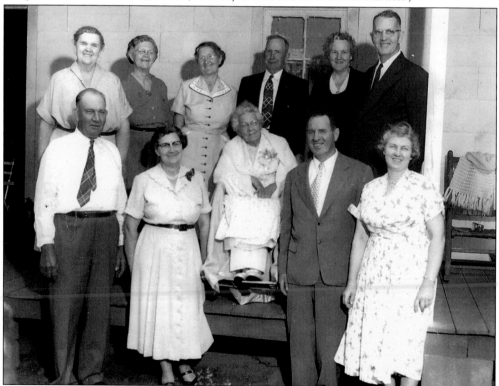

**"AUNT" ELLA HAGER AND FAMILY.** Members of the Hager family stand around "Aunt" Ella Hager for this family photograph during the early 1950s. Members of the family, from left to right, are (front row) Dewey Hager, Lucy Hager, "Aunt" Ella, Pink Sifford, and Louise Sifford; (back row) Maggie Pryor, Lula Carter, Julia Williamson, George Hager, Hattie Hager, and John Hager. (Courtesy of Frances Hampton.)

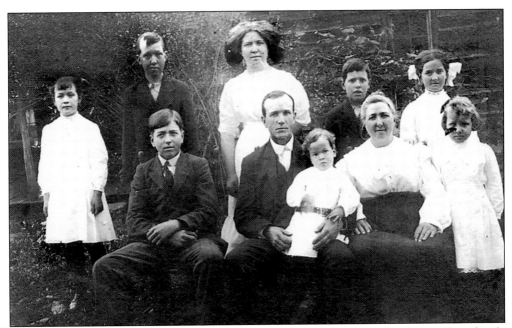

JOHN ROBERT GOINS FAMILY, C. 1910. Members of the John R. Goins family pose for a family photograph around 1910 in front of their home in the Reepsville Community. The home is near the present day Union Elementary School. The family, from left to right, are (front row) Thomas Edney Goins, John Robert Goins, John William Goins, Sarah Alice Goins, and Minnie Elizabeth Goins; (back row) Rosa Ethel Goins, Elbert Eugene, Katie Maude, Maurice Henry Goins, and Mary Alice Goins. (Courtesy of Lincoln County Museum of History.)

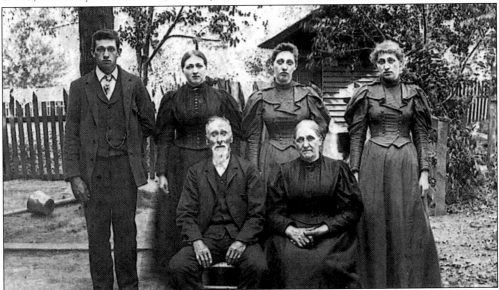

ROBERT MICHAEL PETRIE FAMILY, C. 1900. The Robert M. Petrie family stands close to their family home in the Reepsville Community of western Lincoln County. Members of the family are identified, from left to right, as follows: (front row) Robert Michael Petrie and Eliza Katherine Yoder Heavner Petrie; (back row) Robert William Petrie, Sarah Alice Petrie, Minnie Jane Petrie, and Rosa Petrie. (Courtesy of Lincoln County Museum of History.)

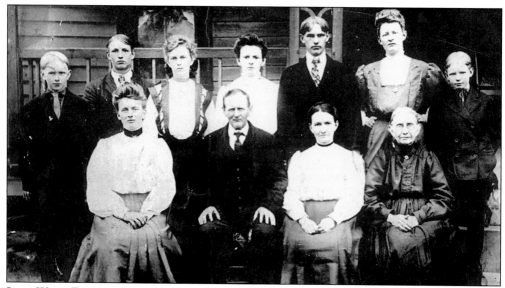

JOHN WOOD FAMILY, C. 1905. John Pinkney "Pink" Wood and his wife, Mary Lyons Wood, raised their family on a 227-acre farm. Pink inherited the farm from his father, John Henry Wood, in 1891. Members of the John Pinkney Wood family, from left to right, are (front row) Bulah Alice Wood Ramseur (1882–1974), John Pinkney Wood (1851–1933), Mary Pauline Lyons Wood (1856–1935), and Annie Beam Lines (Mary's mother); (back row) Lander Wood, Fred Caleb Wood (1892–1957), Sarah Katie Wood Hill (1886–1975), Anna Keever Wood Johnson (1884–1981), John Ernest Wood (1890–1953), Georgia Susan Wood Dennard (1888–1972), and Henry Kiser Wood (1896–1982). (Courtesy of Lincoln County Museum of History.)

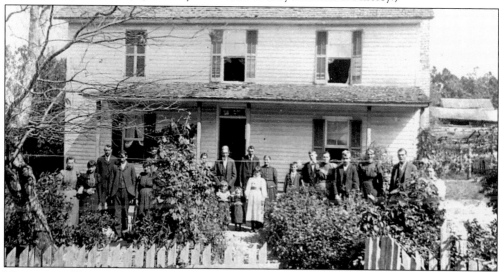

MILTON AND RACHEL SUMMEROW CAMPBELL HOMEPLACE AND FAMILY. A large group of people from the Campbell family stand in the front yard of their unassuming frame house for this photograph taken in the late 1890s. The house was located on land where the current North 321 Volunteer Fire Department currently stands. Milton Campbell (1834–1901) was the son of James Campbell (1814–1866) and Elizabeth Abernathy Campbell. Milton's wife, Rachael Summerow (1831–1908) was the daughter of Jacob Summerow (1801–1880) and Barbara Hallman. (Courtesy of Bobby Campbell.)

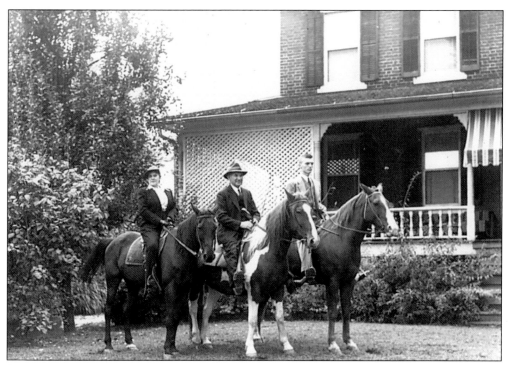

**The Rhyne Family and Their Horses.** Mr. and Mrs. Paul Rhyne Sr. and son Joe pose atop their horses in the front yard of their home in the Laboratory area of Lincolnton. This photograph was taken during the 1950s. (Courtesy of Lincoln County Museum of History.)

**Ramseur Reunion Program, July 4, 1940.** The Ramseur family is one of the first pioneer families to settle in what is now Lincoln County. To celebrate the history and heritage of their family, they held one of many reunions in Lincoln County on July 4, 1940. As part of the reunion's agenda, the family presented a portrait of Maj. Gen. Stephen Dodson Ramseur to the Lincolnton High School Auditorium. This presentation was made the day the Lincoln County School System dedicated the auditorium. The Lincolnton High School Glee Club presented the special music. Mrs. Lena Graham, U.D.C. Historian, introduced Judge Michael Schenck as the featured speaker, and Wiley M. Pickens, superintendent of Lincolnton City Schools, accepted the portrait. The Ramseur portrait is now part of the permanent collection of the Lincoln County Museum of History. (Courtesy of Lincoln County Museum of History.)

## PROGRAM

PRESENTATION OF
STEPHEN DODSON RAMSEUR PORTRAIT
AND

# RAMSEUR REUNION

LINCOLNTON HIGH SCHOOL AUDITORIUM
JULY 4th. 1940

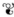

| | |
|---|---|
| *Special Music* .......................... | High School Glee Club |
| *Invocation* ................................ | Rev. A. B. McClure |
| *Introduction of Speaker* ................... | Mrs. Lena Brown |
| | U.D.C. Historian |
| *Presentation of Portrait* ............... | Judge Michael Schenck |
| *Acceptance* ................................ | Wiley M. Pickens. |
| | Supt. Lincolnton City Schools |
| *Vocal Duet* ........................... | Charles and Jack Ramseur |
| *Violin Solo* ............................... | Melvin Sipe |

(Those interested in the Ramseur Reunion Program are cordially
invited to remain).

| | |
|---|---|
| *Welcome of Guests* .......................... | Jno. C. Ramseur |
| *Remarks* .............................. | Mrs. Addie G. Barnieau |
| *Mixed Quartet* .............................. | Four Ramseurs |
| *Biographies* ... H. Lee Ramseur, Arthur Ramseur, J. M. Bernhardt, | |
| Dr. David S. Ramseur, Mrs. Gertrude Morrison Faught | |

BUSINESS AND ORGANIZATION ANNOUNCEMENTS:
*Song* .................. 1st verse of America, audience standing

Picnic Dinner

Motorcade to Battle Ground and Ramseur Cemetery.

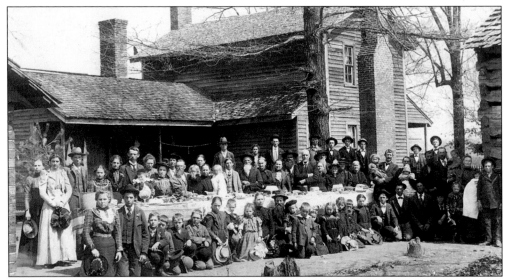

**LUTES GOLDEN WEDDING ANNIVERSARY.** It was a big day for the Noah D. Lutes family in early 1900 when the family gathered for the 50th wedding anniversary of Rosanna Gilbert and Noah Lutes. The two were married on March 28, 1850, and lived near the Catawba County line. The family had a similar gathering in October 1897, when Noah was 70 years old. At that time, 12 of their 13 children were living. They were Alonzo, Benjamin, Andrew, Samuel, Sallie (married J.A. Witherspoon), Annie (married W.F. Reep), Sidney, Mattie (married Marcus Rudisill), Eli, Alfred, Jennie (married J.E. Adams), and Linnie. (Courtesy of Lincoln County Museum of History.)

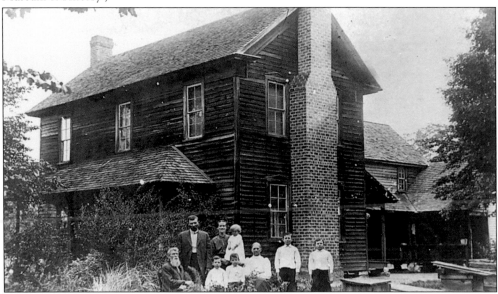

**DANIEL FRANKLIN AND ELANY M. HOOVER WISE HOUSE AND FAMILY.** Posing beside their house on present-day Cat Square Road in western Lincoln County, from left to right, are (front row) Daniel F. Wise (1847–1922); Herman Houston Wise (1909–1983); Loy Ralph Wise (1907–1980); Elany M. Hoover Wise (1849–1924); Ernest Evan Wise (1903–1970); and Elmer Charles Wise (1905–1978); (back row) Michael Mayberry Wise (1870–1983); and Margaret Elizabeth Richards Wise (1872–1925). (Courtesy of Helen Peeler.)

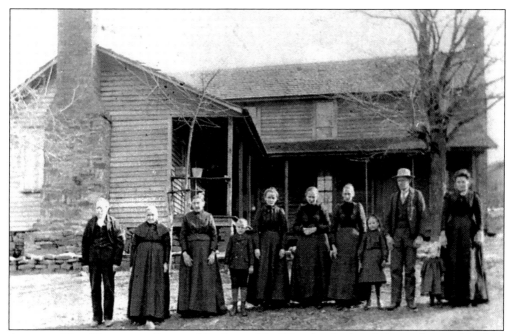

ABSOLOM WISE HOUSE AND FAMILY. Members of the Wise family, from left to right, are Absolom Wise, Polly Ann Rhyne Wise, Sarah Ann Wise, Marshall Leonhardt, Adaline Wise, Margaret Wise Leonhardt, Mary Catherine Wise, Ila Leonhardt, George T. Wise, Robert G. Wise, and Minnie Wise. (Courtesy of Helen Peeler.)

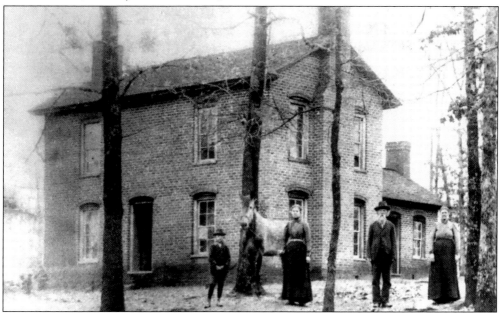

EDNEY AND MARY CATHERINE DELLINGER HOOVER HOUSE. Members of the Hoover family have their family photograph taken in front of their brick house, built c. 1883. The house still stands on Hoover-Elmore Road in western Lincoln County. Members of the family, from left to right, are unidentified, Fanny Ellen Hoover Houser (1877–1967), Edney Hoover (1837–1908), and Mary Catherine Dellinger Hoover (1841–1929). (Courtesy of Helen Peeler.)

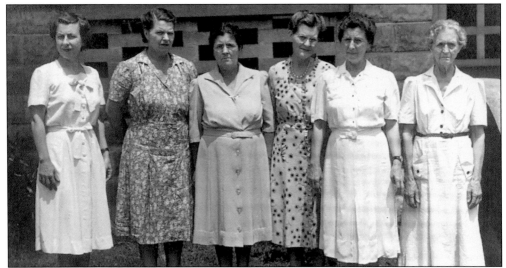

**Juniata Wilson Hoover and Daughters.** Pictured from left to right are Edna Althea Hoover Branch (1903–1994), married Preston Branch; Edith Alicia Hoover Johnston (1903), married Joab F. Johnson; Sally Wilhelmenia Hoover Wise (1898–1961), married Robert G. Wise; Margaret Annie Hoover Hoffman (1893–988), married Ernest J. Hoffman; Katie Lee Hoover (1888–1976); and Juniata Wilson Hoover (1869–1953), married John Edney Hoover. (Courtesy of Helen Peeler.)

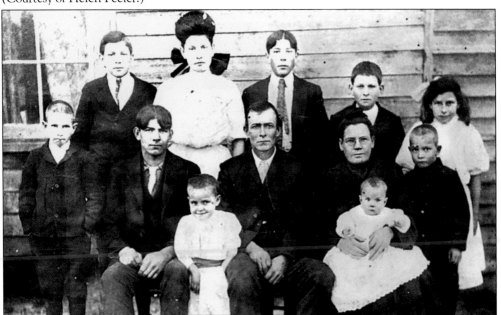

**Thomas Monroe Hoover Family.** Thomas Monroe and Mary Etta Hoover pose with their family for this photograph, taken c. 1910. From left to right are (front row) Charles Lee (1900–1987), Henry Hampton (1890–1970), Nettie Arlee H. (Lutz) (1904–1989), Thomas Monroe Hoover (1868–1941), Mary Etta Helms Hoover (1871-1954), Addie Carrie H. (Leatherman) (1907–1995), and William Thomas (1902–1946); (back row) Marvin Clarence (1892–1978), Georgia Lavada H. (Sain) (1889–1983), Pinkney Austin (1894–1962), Dennis Edney (1896–1979), and Catherine "Katie" Bell H. (Kiser) (1898–1985). (Courtesy of Helen Peeler.)

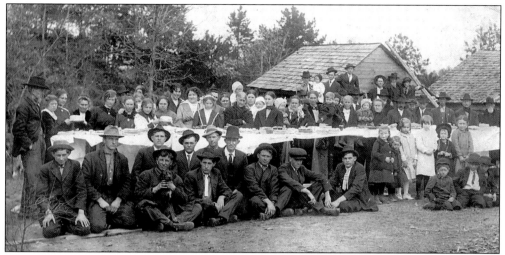

HOUSER BIRTHDAY AND REUNION. In western Lincoln County, the Houser family congregates around a large line of tables, filled with food and drinks. They have gathered for a birthday and reunion celebration during the first decade of the 20th century. Although everyone in attendance cannot be identified, Willie Hull and Will Houser can be seen on the front row. (Courtesy of Lincoln County Museum of History.)

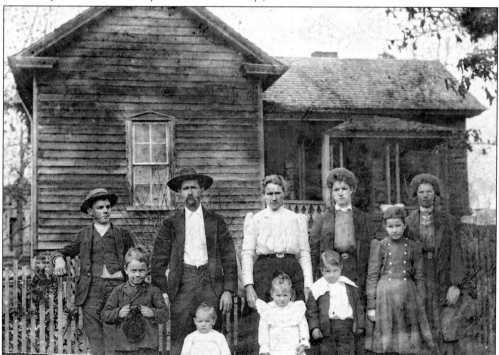

THEODORE "THEE" FRANKLIN AND SUSAN BEAM HOUSE AND FAMILY. Thee Beam built the house pictured above around 1890. Members of the Beam family, from left to right, are (front row) T.F. "Hall" (1902–1970), Bonnie B. Tillman (1908–1997), Millie B. Gantt (1906–1972), Kemp (1904–1979), and Maude B. Engle (1898–1971); (back row) Russell (1895–1962), Thee (1867–1957), Susan Shuford Beam (1867–1910), Bryte B. Tillman (1891–1966), and Ola B. Biggerstaff (1893–1970). (Courtesy Barbara Dayberry.)

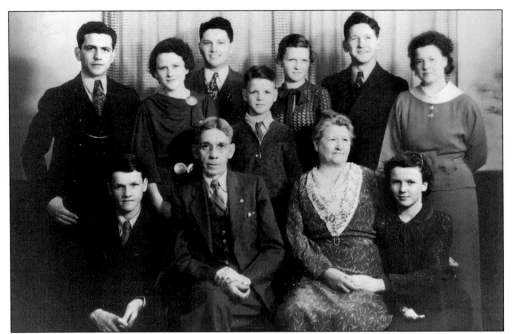

**HARRY AND ADDIE HEIM PAGE FAMILY.** The Page family is finely-dressed for this photograph taken around 1928 at their home, today known as 605 North Laurel Street in Lincolnton. Members of the Page family, from left to right, are (front row) Jim Page, Harry Page, Addie Heim Page, and Jane Page Little; (back row) Harry Page, Ann Page Webster, Paul Page, William Page, Addie Mae Page, George "Bud" Page, and Mary Page. (Courtesy of Edward Little.)

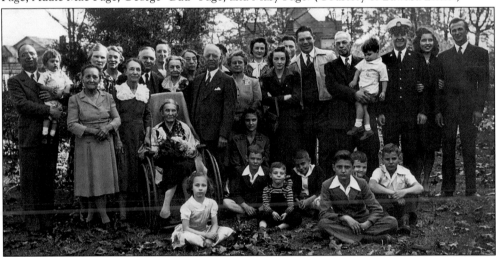

**LITTLE FAMILY, C. 1942.** Members of the Little family assembled at the family home in Hickory around 1942 for this photograph. The great grandchildren of Candace A. Little sit "Indian style" in the foreground. Members from left to right are (first row) Blanche Little Pegram, Alla Pearl Little, Candace A. Little, Candace Herman, Clarence S. Little, Elvira S. Little, Rachel Hefner, Harold Little, Walter Hefner, Franklin Little, Ermintrude Mullen, Lester Mullen, and Tom Shulley; (back row) Marcus Leopold Little, Lester Alfred Mullen, Florence Rhyne Little, Jennie Lee Little Hefner, Herbert Little, Hermine Little Childs, Mabel Little, Evangeline Little, and Walter Lee Hefner. (Courtesy of Edward Little.)

44

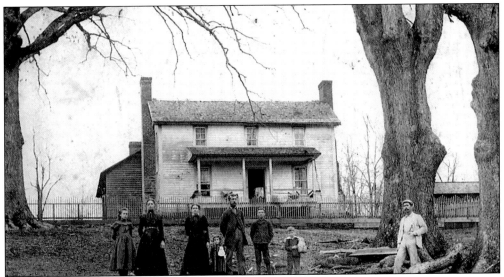

OLD JACOB RAMSEUR WARLICK HOUSE, LINCOLNTON, REEPSVILLE ROAD. The Jacob Ramseur and Emma Wharton Warlick family stand in the foreground of this photograph taken around 1898. It was on this site that pioneer Daniel Warlick built his house in the 1750s. The site is now occupied by the Cliff Rhyne home. Members of the Jacob and Emma Warlick family are, from left to right, as follows: Ruth Warlick (Mrs. Orie Rhea); Clare Warlick (Mrs. Luther Yoder); mother Emma Warlick (Emma Wharton of Guilford County, North Carolina); Virge Warlick (Mrs. Hugh Holly); father Jacob Ramseur Warlick; Roy Warlick (twin to Ruth); and Hugh Warlick.(Courtesy of Louise Warlick Carlton.)

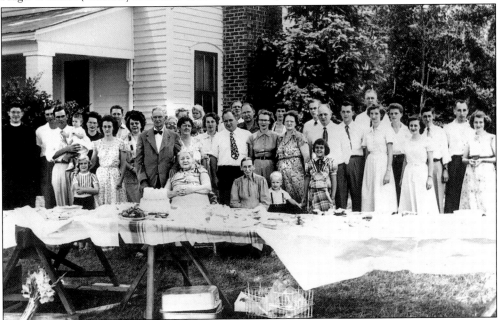

WISE 50TH WEDDING ANNIVERSARY. Members of the George Theodore and Minnie Lelia Wise family congregate beside the Wise family home to celebrate the couple's 50th wedding anniversary in 1950. The house is located on Highway 27 West in the Howard's Creek Community of western Lincoln County. (Courtesy of Helen Peeler.)

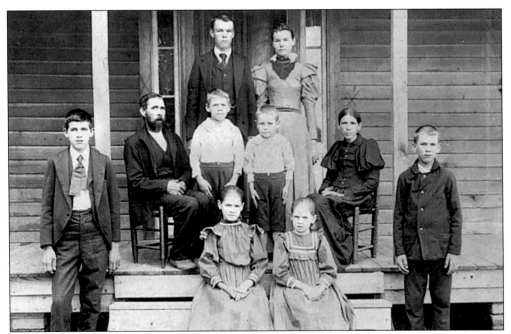

JULIUS ALEXANDER AND MARY CATHERINE CARPENTER WISE FAMILY. The Wise family chose the front porch of their house as the backdrop for this late 19th–century photograph. Members of the family, from left to right, are (front row) Luther Nathan Wise (1881–1939), Alice Mae Wise (1888–1954), Eula Wise (b. 1892), and Thomas Burton Wise (1883–1956); (middle row) Julius Alexander Wise (1852–1940), Jasper Lee Wise (1890–1981); Marshall Evan Wise (1893–1988), and Mary Catherine Carpenter Wise (1857–1899); (back row) Jacob L. Wise (1878–1900) and Nona Ida Wise (1876–1958). (Courtesy of Helen Peeler.)

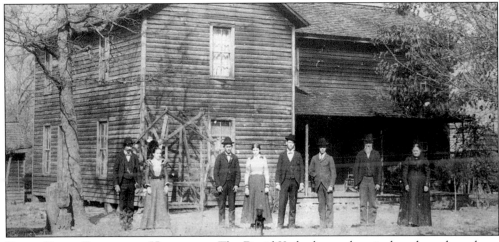

DAVID YODER FAMILY AND HOMEPLACE. The David Yoder homeplace is thought to have been built by his father Solomon Yoder (1805–1854). It stood on Daniels Church Road in western Lincoln County. D.A., David's son, came to Lincolnton in the early 1900s. Members of the family are, from left to right, as follows: D.A. Yoder (1871–1950), Emma Yoder (D.A.'s wife), Robert Lee (1875–1949), Lizzie Yoder Coon (1883–1939), William Michael (1878–1939), Martin Luther (1880–1961), David (1844–1911), and David's second wife Catherine Sain Yoder (1837–1906). (Courtesy of Sarah Yoder.)

HALLMAN FAMILY, 1950S. Sometime during the 1950s, the Hallman family assembled at Daniels Reformed Church for a family reunion. Some members of the Hallman family were members at Daniels, and others were members at Lincoln Avenue Baptist Church. The family alternated between the churches each year for their family reunions. Members of the family are identified from left to right, as follows: June Hallman, Clarence Hallman, Margie Hallman, Ida Hallman, Winslow Hallman, Addie Hallman, Paul Hallman, Arie Hallman, Ruth Hallman, Dan Hallman, Loy Hallman, and Ernest Hallman. (Courtesy of Louise Reynolds.)

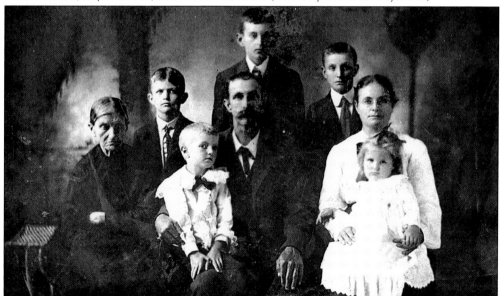

LOGAN J. AND ALICE W. REEP FAMILY. Luther Jones Reep (1899–1971) and Catherine Katy Reep (b. 1903) sit in their parents' laps for this studio photograph taken c. 1906. The other family members, from left to right, are Malina "Linny" Speagle Reep (1824–1914), Charley Reubin Reep (1897–1909), Jacob Alba Reep (1890–1970), Logan Jacob Reep (1858–1914), Clarence E. Reep (1894–1963), and Alice Ward Reep (1866–1957). (Courtesy of Jacob Reep.)

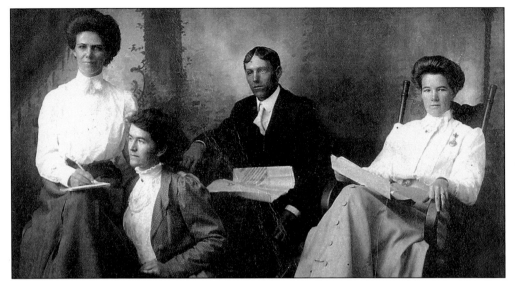

**THE PATTONS, LINCOLNTON, 1908.** On a trip from Morganton to Lincoln County to visit her in-laws, a new bride proudly displays her wedding ring in the 1908 photograph taken by photographer Arther J. Patton at Patton's Studio in Lincolnton. Pictured, from left to right, are Florence S. Patton, Hallie Hoke (daughter of Minnie Patton Hoke), and newlyweds Herbert H. Patton and wife Mary Hester (Orders) Patton. (Courtesy of Ann M. Dellinger.)

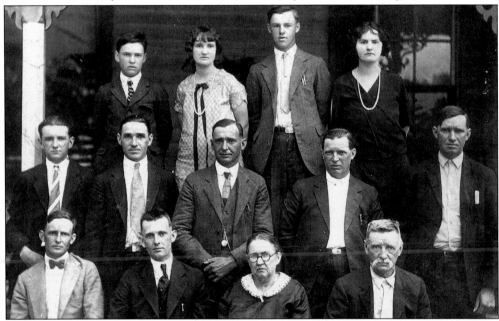

**DAVID JAMES AND MARGARET WEHUNT BEAM FAMILY.** Members of the D.J. and Margaret Beam family assembled on their front porch for this photograph taken in 1924. Family members, from left to right, are (front row) Floyd (1899–1962), Clyde (1892–1989), Margaret Wehunt (1867–1935), and David James (1861–1947); (middle row) Thern (1910–1982), R.L. "Bub" (1894–1986), Cletus (1889–1960), Lester (1887–1976), and Frank (1885–1954); (back row) Pence (1912–1994), Blanch Beam Wooley (1905–1982), D.J. Jr. (1908–2001), and Susan Beam Stamey (1903–1968). (Courtesy of Pauline Beam.)

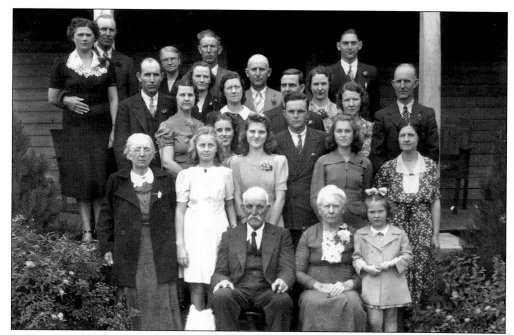

**LUTHER AND EMMA SHRUM'S 50TH WEDDING ANNIVERSARY, MAY 12, 1939.** Members of the Shrum family celebrated the 50th wedding anniversary of Luther and Emma Shrum. Those in attendance, from left to right, are (first row) Luther A. Shrum, Emma H. Shrum, and Phyllis H. Reinhardt; (second row) Emaline Shrum, Barbara S. Blanton, Lucy S. Ramseur, Elizabeth S. Little, L.P. Shrum, Mary S. Bower, and Ethel Shrum; (third row) Etta B. Shrum, Bessie B. Shrum, Everette Shrum, Lawson Rhyne, Mae S. Honeycutt, Bess S. Rhyne, and Louie Shrum; (fourth row) Helen W. Shrum, Burgin Shrum, John Shrum, Ada Shrum, Vivian B. Shrum, Frank Shrum, and Harold Honeycutt. (Courtesy of Leonard and Barbara Blanton.)

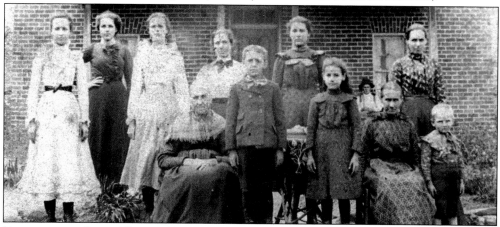

**FRANKLIN AND SARAH HOUSER FAMILY AND HOUSE.** Franklin A. Houser (1826–1878) built this house from bricks he made on his property sometime before the Civil War. Members of the Houser family, from left to right, are Delia H. Gladden (1883–1932), Cora H. Shidal (1886–1986), Katie H. Mitchem (1888–1934), Sarah "Sally" L. Houser (1830–1911) (seated), Emma H. Mitchem (1878–1962), Charles F. (1891–1975), Minnie H. Shidal (1881–1966), Hattie Houser (1894–1991), Susan C. Houser (1859–1934) (seated), Julia H. Beam (1877–1966), and Bryce Beam. John Haynes is seated on porch in the background. (Courtesy of Bill Beam.)

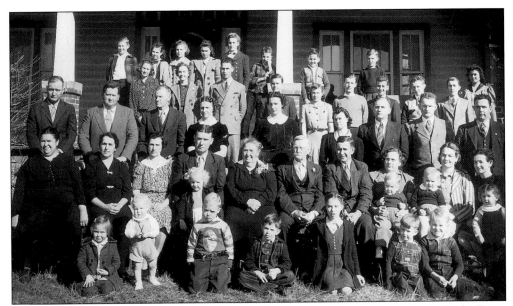

**BEAM 50TH WEDDING ANNIVERSARY.** George Lee (1863–1951) and Georgia Ann Jenks Beam (1868–1954) are seated for this photograph in 1940 in front of their home in western Lincoln County. Their children include Pearl Dora B. Leatherman (1893–1976), Zonia B. Wehunt (1892–1993), Edna B. Hull (1897–1993), Hugh (1899–1978), David Rush (1901–1993), Annie Susan B. Boyles (b. 1904), Geneva B. Taylor (1906–1997), Corinne B. Boyles (b. 1906), and Madge B. Houser (1911–1998). (Courtesy of Corinne Boyles.)

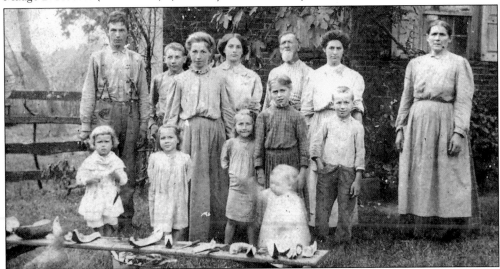

**SEAGLE FAMILY.** Members of the Seagle family stand in the foreground of this photograph taken around 1910 in front of the old Rev. Alfred J. Fox place. From left to right are (first row) Willard Yoder, Sarah May "Sallie" Seagle (b. 1906), Margretta Seagle (b. 1904), and Loy Reep (b. 1900); (middle row) Mary Ellen Seagle Reep (1888–1969), Lois Pearl Seagle (b. 1899), and Alfred Michael Seagle (b. 1901); (back row) W.M. Seagle's arm (1861–1948), John Franklin Seagle (b. 1893), Daniel Alexander Seagle (b. 1895), Katie Ethel Seagle (b.1891), grandfather Daniel A. Yoder Sr. (1834–1927), Rosa Emaline Seagle (1890–1969), and mother Seagle (Mrs. Minta Yoder Seagle) (1866–1964). (Courtesy of Lincoln County Museum of History.)

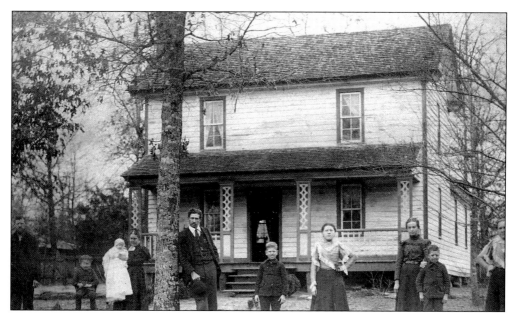

**GEORGE P. RHYNE FAMILY.** George P. Rhyne bought this farm in 1871 from the heirs of John and Catherine Loretz Motz. On this site, he built his house and ran a general store. It is located near Union Elementary School in western Lincoln County. Members of the family are thought to be George P. (1857–1948), Ellis (1894–1954), Ethel R. Garrison, Mary Plonk Rhyne (George's second wife) (1860–1932), Robert Petrie (neighbor), Frank, Mary R. Goodnight (1875–1933), Lizzie R. Hartsoe, Evan (1891–1919), and Ida R. Leatherman (1800–1908). (Courtesy of Mary Ethel Ward.)

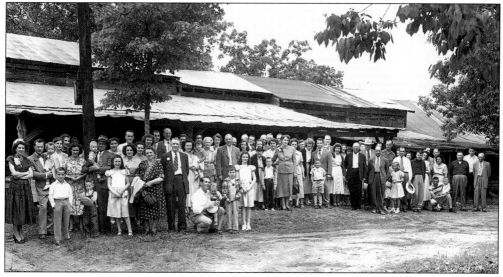

**SMITH-LINEBERGER REUNION AT ROCK SPRINGS CAMPGROUND, DENVER.** The tents at Rock Springs Campground in Denver (Lincoln County) provide a fitting background for the 1950 Smith-Lineberger reunion. Begun in 1794 by Rev. Daniel Asubry during the Great Revival Movement in the United States, Rock Springs Campground was moved to its present site in 1830 from the Rehoboth area in eastern Lincoln County. Rock Springs Campground is listed on the National Register of Historic Places. (Courtesy of Lincoln County Museum of History.)

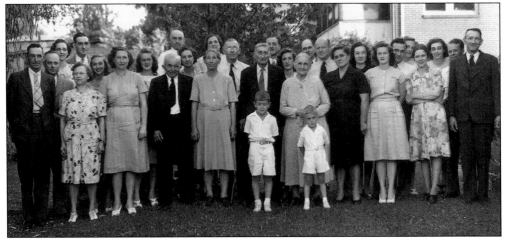

REEP-SEAGLE-CRAIG REUNION, 1950S. Members of the Reep, Seagle, and Craig families gather for a group photograph during a family reunion. Max Seagle and Douglas Craig stand in the foreground as the only youngsters in the group. Family members are identified, from left to right, as follows: (front row) John Seagle, Edith Leonard Seagle, Margretta Seagle, Will Reep, Mary Ellen Reep, William Maxwell Seagle, Minta Yoder Seagle, Lois Seagle Craig, Mildred Craig Gates, Annie Laurie Seagle, and Dan Seagle; (middle row) Harold Craig, Minta Carpenter, Jean Craig, Rose Seagle Carpenter, Loy Reep, J. Ann Yount, Doug Craig, Carolyn Yount, Hub Gates, Inez Carpenter, and James Craig; (back row) Sallie Seagle Yount, Ernest Yount, Sam Carpenter, Kate Seagle Carpenter, A.M. Seagle, and Joe Collins (a friend of A.M. Seagle's from Salisbury, North Carolina). (Courtesy of Helen Peeler.)

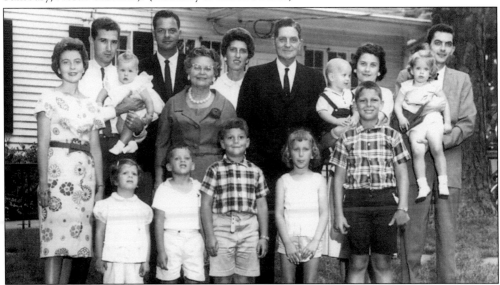

HUBERT AND BEULAH CRAIG FAMILY. The Hubert and Beulah Craig family stands on the lawn of their home on South Aspen Street in Lincoln County for this photograph taken in the 1960s. Hubert Maxton Craig Sr. and Beulah Rimmer Craig moved to Lincolnton from Stanley, North Carolina, in the summer of 1944. Hubert Craig was born in 1903 in McColl, South Carolina. He graduated from Mt. Holly High School and attended Kings Business College. He was an organizer of Lincoln National Bank where he served as vice president from 1948 to 1958, when he became president. (Courtesy of Nancy Hollingsworth.)

# *Three*

# BUSINESS AS USUAL

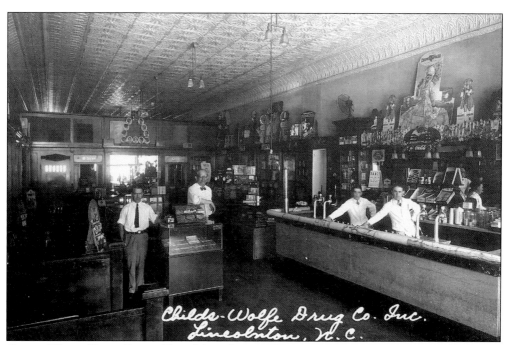

**CHILDS-WOLFE DRUG STORE, EAST MAIN STREET, LINCOLNTON.** Dr. E. Drayton Wolfe (1877–1931) opened his drug store in downtown Lincolnton during the 1920s. Dr. Wolfe included his wife's last name, Bessie Childs, when he incorporated his drug store. Four gentlemen stand in the drug store for this photograph taken around 1924. The men are identified, from left to right, as follows: Franklin Craig Seagle (1895–1964), Dr. Wolfe, Murton M. Rudisill (1886–1949) and Loy John Reinhardt (1907–1933). (Courtesy of Peggy Moore.)

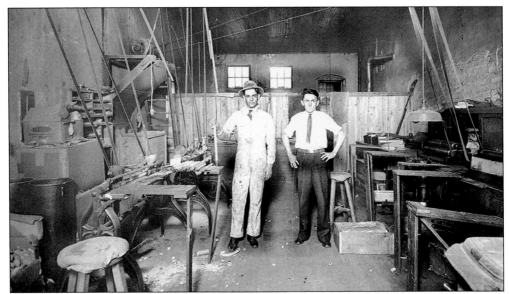

**CAROLINA ROLLER SHOP, LINCOLNTON.** Odell Harvey first opened Carolina Roller Shop in Maiden in 1935. He moved the business to East Sycamore Street in Lincolnton in 1938, and finally to North Aspen Street in 1950. During the 1950s, Carolina Roller Shop repaired and recovered rollers for nearly 150 textile mills within a 100-mile radius of Lincolnton. The majority of their customers were located in North Carolina, but they did business with textile mills in Virginia, South Carolina, and Georgia. At the time of this photograph, Carolina Roller employed 14 men with more than 35 years experience covering textile rollers. Odell Harvey and an unidentified man stand in the Carolina Roller Shop for this photograph taken when the shop was located on East Sycamore Street. (Courtesy of Mack Harvey.)

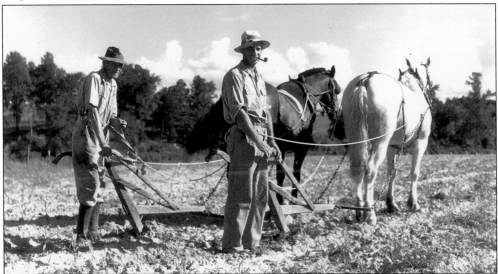

**EDWARD W. MULLEN AND ROBERT H. DELLINGER JR. IN THE FIELD.** Taking a break from plowing are Edward W. Mullen and his son-in-law Robert H. Dellinger Jr. This photograph was taken in 1945 at the Mullen family farm in Crouse. Edward Mullen and Robert H. Dellinger helped organize Lincoln County's unit of the Farmers Cooperative Exchange. (Courtesy of Robert Dellinger.)

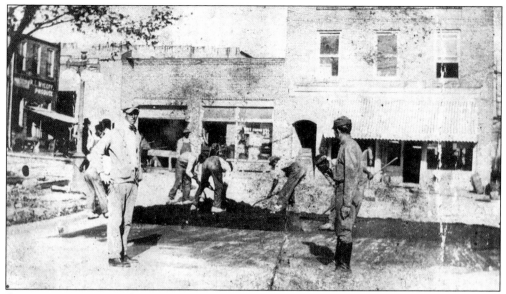

**GOING MODERN.** Lincolnton's streets were dirt until around 1920. East Main Street was the first to be paved with asphalt. Shown here are pavers putting down a coat of asphalt around the courthouse, probably in 1921. The first paved road in the county was US 321 north of Lincolnton in 1924, followed by the section south of Lincolnton in 1925, N.C. 27 east of Lincolnton in 1925, N.C. 150 toward Cherryville in 1926, N.C. 27 west of Lincolnton in 1930, and N.C. 150 toward Mooresville in 1934. (Courtesy of David C. Heavner.)

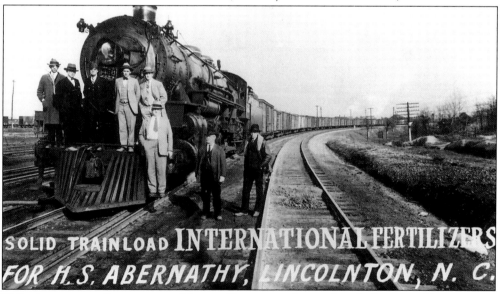

**H.S. ABERNATHY, LINCOLNTON, NORTH CAROLINA.** An unidentified group of businessmen stand on the railroad tracks and on the train for this early 20th–century photograph. This picture served as an advertisement for H.S. Abernathy's "Solid Trainload International Fertilizers." Harold (Hal) Smith "H.S." Abernathy was born on April 21, 1896, in Stanley, North Carolina. Hal went into business with B.J. "Bup" Ramsaur and formed Abernathy and Ramsaur coal business. The two men also built houses and developed property. Hal died on April 8, 1945. (Courtesy of Lincoln County Museum of History.)

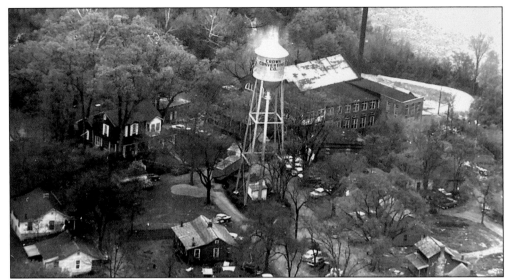

CROWN CONVERTING COMPANY, LINCOLNTON. The large water tank bearing the name Crown Converting Company towers above the mill and village. At the confluence of the South Fork River and Clark's Creek in Lincolnton, the mill building was operated as Laurel Hill Cotton Factory by Andrew Motz and E.S. Barrett. It was known as Ivy Shoals Cotton Mill under the ownership of Col. John F. Phifer and Col. R.W. Allison. The mill was named Elm Grove Cotton Mill when owned by Robert S. Reinhardt and Stephen Smith, and it became Crown Converting Company under William M. Lentz and Edgar "Cap" Love. (Courtesy of Edgar Love III.)

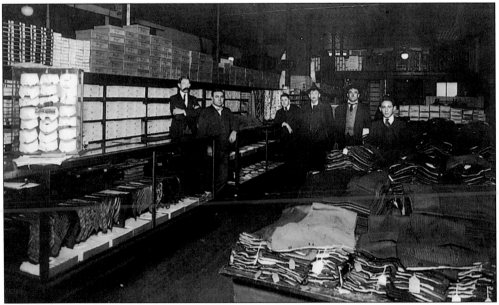

INTERIOR OF DAVE LERNER'S CLOTHING STORE, EAST MAIN STREET, LINCOLNTON. Dave Lerner was born in 1896 to Shimshon and Tova Rivkah Lerner in Uskowice, Przemyslany, Austria-Hungary—a region later to become Poland. Dave's brother Isaac brought him to America in 1913. He opened his clothing store on East Main Street in Lincolnton in 1924 and remained in business for 56 years. (Courtesy of Lincoln County Museum of History.)

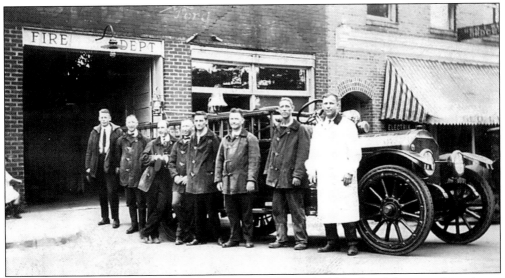

LINCOLNTON FIRE DEPARTMENT, 1920S. Prior to the mid-1890s, fire fighting in Lincolnton was "everybody's business." When a fire occurred, all persons in the vicinity helped control and extinguish the fire with whatever means and equipment happened to be available. In the late 1890s and early 1900s, an organized company of black men formed the Lincolnton Fire Department. Henry Taylor served as chief. In 1907, a volunteer fire department was organized. The first fire truck arrived in town on December 11, 1917. A new 750 gallon–pumper tank was delivered on September 25, 1925. The Lincolnton Fire Department members stand in front of the station on East Main Street alongside one of the first fire trucks. (Courtesy of Lincoln County Museum of History.)

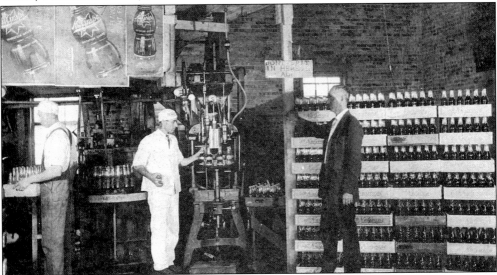

LINCOLNTON'S LITHIA BOTTLING WORKS. In the 1920s, local residents could quench their thirst with a soft drink from Lincolnton's Lithia Bottling Works. Among the firm's popular products were NuGrape, Orange Snap, Jackson Peach Blend, and Celery Cola—all manufactured with water from the Lincoln Lithia Springs. This photograph, captured in 1925, depicts proprietor Robert H. Dellinger Sr. with employees Lee Seagle, operating the bottling machinery, and Levy Hallman, packing bottles into crates. (Courtesy of Robert and Ann Dellinger.)

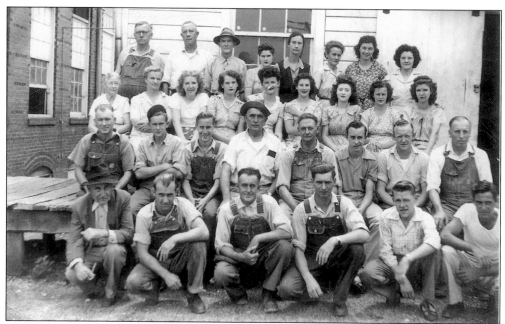

**GLENN MILLS, FORMERLY SAXONY MILL, C. 1943.** During the 1940s, with World War II raging overseas, women saw more work in the textile industry, as evidenced by this photograph of Glenn Mills workers taken around 1943. The mill is located off of North Grove Street in Lincolnton. Henry Grayson, mill supervisor, rests in the middle of the second row, wearing his hat and pocket protector. The Saxony Mill changed hands over the years, becoming Glenn Mills, and finally Carolina Mills. (Courtesy of Louise Reynolds.)

**RHODES-RHYNE MILL, LINCOLNTON.** David Polycarp Rhodes and his son operated Rhodes-Rhyne Mill in Lincolnton from the early 20th century until the 1970s. The two also managed Indian Creek Mill in Lincolnton. David P. Rhodes built his home at 604 South Aspen Street (now 1022). He married Juetta Thornburg of Dallas and had seven children. (Courtesy of John and Betty Gamble.)

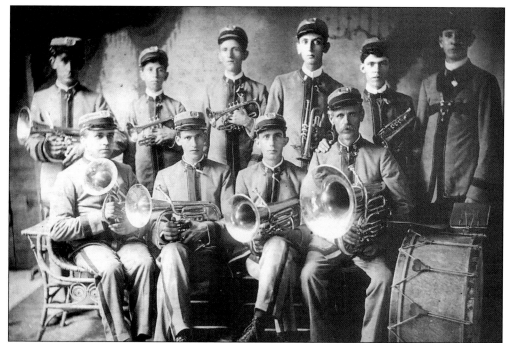

REEPSVILLE BAND, 1907. The thriving turn-of-the-century community of Reepsville, in western Lincoln County, was named for Phillip A. Reep (1841–1904). Reep became postmaster in 1884, and the post office changed from Pleasant Home to Reepsville. The Reepsville Band, pictured in 1907, are from left to right (front row) Max Reep, Lester Carpenter, Calvin R. Warlick, and Tom Horne, bandmaster; (back row) Thomas A. Warlick, W. Farrell Warlick, James D. Warlick, Roy Warlick, and two unidentified persons. (Courtesy of Ruth W. Leonard.)

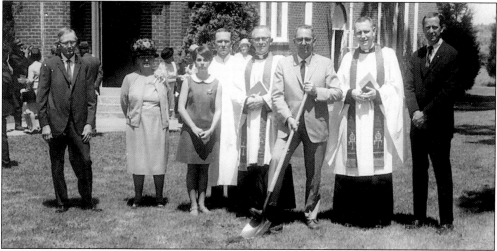

CEDAR GROVE LUTHERAN CHURCH GROUNDBREAKING, VALE, 1968. Pastor Aaron Lippard and a representative from the North Carolina Synod stand in 1968 with members of the Cedar Grove Lutheran Church in Vale, western Lincoln County, for the groundbreaking of their new sanctuary. The names of those assembled are, from left to right John M. Beam Sr., Camilla D. Beam, Candy Shidal, Carl A. Beam, Pastor Aaron Lippard, Hoyt Shidal, North Carolina Synod Representative, and Ralph Anthony. (Courtesy of Cedar Grove Lutheran Church Archives.)

LINCOLNTON'S HANDY MAN: HUGH RAMSEUR. Hugh M. Ramseur Sr. was born in Lincolnton in 1900 and resided in an area on East Main Street known as Freedom. Hugh was a faithful employee of Ramseur Hardware Company for 38 years. He installed and repaired heating and cooking stoves and was instrumental in the installation of electric water systems throughout the county. He died in 1962. The Ramseur Hardware was operated at several locations in Lincolnton for 95 years, making it one of the city's longest-running businesses. (Courtesy of Lincoln County Museum of History.)

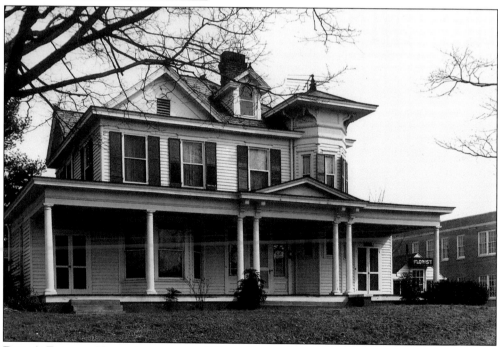

DRUM'S FUNERAL HOME, LINCOLNTON. Elliotte Forrest Drum (1904–1974) moved from Maiden to Lincolnton in 1937 and opened Drum's Funeral Home with his sons Melvin and Shirley on Main Street. During the 1940s, he moved to the house featured in the photograph above, located on Sycamore Street. In 1972, the house was razed and current structure was built. (Courtesy of Lincoln County Museum of History.)

**DOT JOHNSON, NORTH CAROLINA EXTENSION SERVICE.** In this 1962 photograph, Dot Seagle Johnson receives her 20-year certificate of service from John E. Piland, southwestern district extension chairman. Dot was employed by the North Carolina Extension Service in Lincoln County on August 3, 1942, and celebrated her 60-year anniversary in August 2003. Over the years, she has worked with 4 local extension directors, 35 different extension agents, and 18 secretaries. (Courtesy of Dot Johnson.)

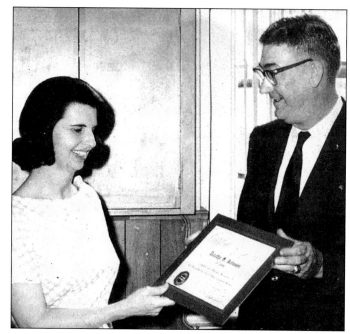

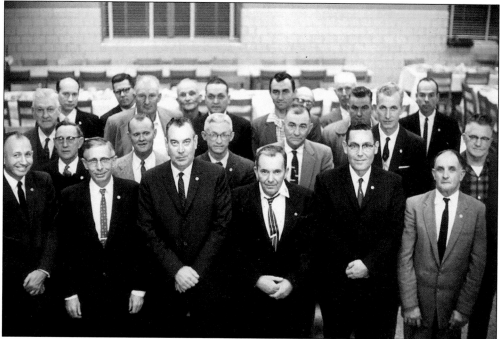

**SETH LUMBER GROUP.** A group of men associated with Seth Lumber Company of Lincolnton assembled for a business meeting during the late 1950s. Members of the company, from left to right, are (first row) Gordon "Shine" Goodson, Fred Auton, Elbert Combs, Clarence Mull, Buford Bumgarner, and Frank Wehunt; (second row) Jake Jenkins, Tommy Craig, Harry Hartman, Frank Howard, Paul Setzer, and Brant Little; (third row) Austin D. Kilham, ? Dellinger, Paul Reep, George Lutz, Clarence Houk, and Clyde Johnson; (fourth row) Wayne Finger, Herman Howard, two unidentified men, and Frank Shrum. (Courtesy of Herman Howard.)

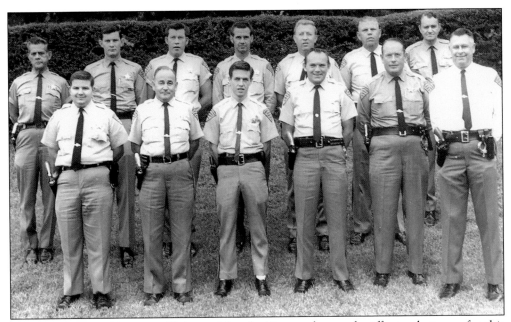

**LINCOLN COUNTY DEPUTIES.** Thirteen Lincoln County deputy sheriffs stand at ease for this photograph taken to familiarize the citizens of Lincoln County with their deputies. According to a newspaper clipping, "the deputies consider their number '13' unlucky only to lawbreakers." The deputies, from left to right, are (front row) Kenneth Rhyne, Lloyd Cooke, R.B. Miller, Leonard Davis, unidentified, and Harven Crouse; (back row) Marshall Sisk, Ray Leonhardt, Ed Hallman, Jack Beam, Pete Sain, Graham Luckey, and Fletcher Whiteside. Sheriff Earlie Norwood is not included in the photograph. (Courtesy of Sallie Lee Luckey.)

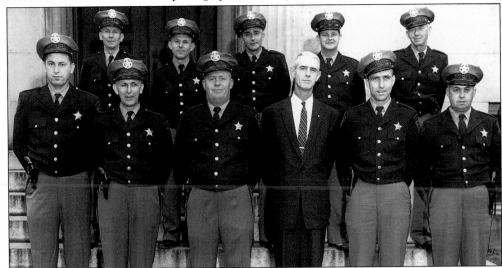

**LINCOLN COUNTY DEPUTIES, DECEMBER 8, 1957.** On a rainy Sunday afternoon, the Lincoln County deputies stood on the south side of the Lincoln County Courthouse to be photographed in the first uniforms. The deputies, from left to right, are (front row) T.J. Tutherow, M.L. Harvell, B. Jack Scronce, Sheriff Frank P. Heavner, Horace A. Gilbert, and Grady Sisk; (back row) Joe King, Gene Heafner, A. Ferd Houser, B.L. "Brownie" Tallent, and J. Carr Yount. Roy Heavner and H.A. Shrum are not pictured. (Courtesy of Lincoln County Museum of History.)

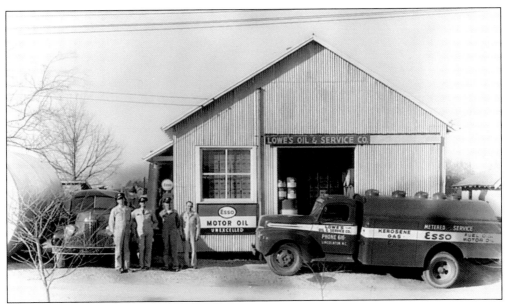

LOWE'S OIL AND SERVICE COMPANY, LINCOLNTON. From the first decade of the 20th century through the 1950s and 1960s, Lincoln County enjoyed the charm, hospitality, and coziness of a small rural business. The Lowe's Oil and Service Company in Boger City (Lincoln County), North Carolina sold the oil that kept many homes all over the county warm throughout the years. Other small stores that number among the ranks of the county's best during this time period include Central Candy and Cigar Company, Cash and Carry Store, Joe's Boxcar Diner, and Corriher Implement Company. (Courtesy of Lincoln County Museum of History.)

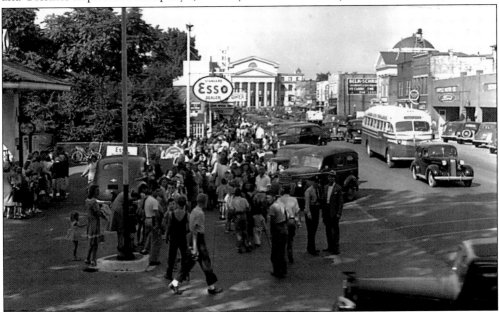

ESSO SERVICE STATION, EAST MAIN STREET, LINCOLNTON. The anticipation for a big event can be assumed from the large group that assembled in front of Esso Service Station in downtown Lincolnton. Located in the second block of East Main Street, Esso was located just across the bridge from Joe's Boxcar Diner. (Courtesy of Lincoln County Museum of History.)

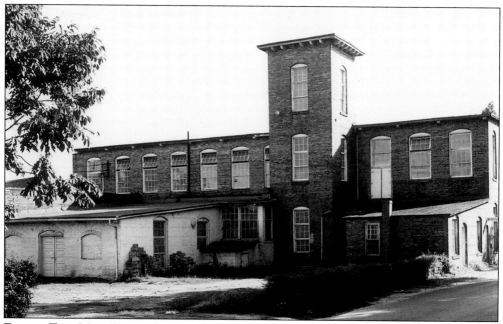

**EUREKA-TAIT MILL, WATER STREET, LINCOLNTON.** The Eureka Company was formed in 1906 by J.L. Lineberger, W.A. Biggs, and L.J. Dellinger. They built this two-story, brick structure on Water Street in Lincolnton between 1907 and 1911 to "manufacture raw and waster cotton into yarn, cloth, twine, and rope." The 14,000-square-foot building was enlarged to 24,000 square feet after Tait Yarn Company bought the structure in 1946. Lincoln Bonded Warehouse, a company associated with the Lineberger family of Lincolnton, bought the building in 1966 and still owns the property. (Courtesy of Lincoln County Museum of History.)

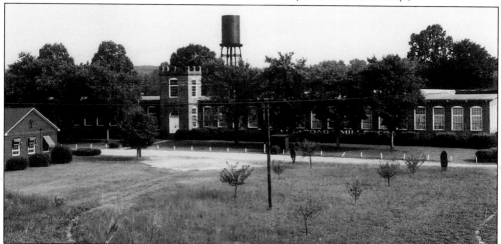

**MASSAPOAG MILL, LINCOLNTON.** Built in 1907 as Rhodes Manufacturing Company by John M. Rhodes, this was the only mill operated during the early 20th century by electric power. Rhodes was also responsible for the 22 mill houses that served the workers who made their living at the mill. E.O. Anderson, Thorne Clark, and David Clark purchased the mill from Rhodes after World War I, renamed it Anderson Mill, Inc., and operated it until 1929. The group renamed the mill Massapoag and wove cotton duck to line shoes. Long Shoals Cotton Mill operated Massapoag from 1957 to 1971. (Courtesy of Lincoln County Museum of History.)

LINCOLNTON WATER WORKS, LINCOLNTON. The Lincolnton Water Works, shown in the photograph above, rests in a large open field that is now the home of South Fork Park Softball field. During the 1950s, the Lincolnton Water Works was administered by a full-time superintendent and three technicians. The water technicians made daily water analyses, and the county sanitarian made periodic tests. Lincolnton's water was supplied by the South Fork, Clarks Creek, Indian Creek, Walker Branch, and five deep wells. The water works had a raw storage capacity of 2,000,000 gallons a day and a pumping capacity of 1,728,000 gallons a day. (Courtesy of Lincoln County Museum of History.)

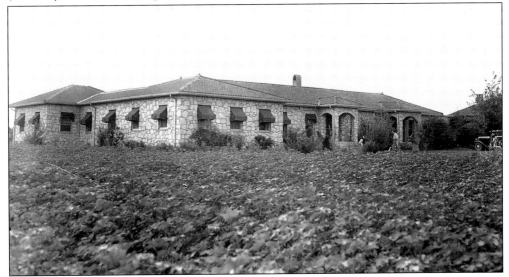

DR. EDWARD'S CLINIC. Doctor F.D. Edwards (1886–1964) made his home and practice in Toluca, North Carolina. Many folks from western Lincoln County took advantage of Dr. Edward's expertise and visited him regularly for doctor's appointments. Dr. Edwards graduated from Atlanta Medical College, later a part of Emory University. (Courtesy of Loretta Justice.)

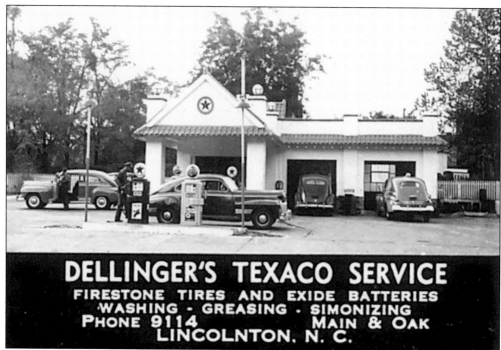

**DELLINGER'S TEXACO SERVICE**
FIRESTONE TIRES AND EXIDE BATTERIES
WASHING - GREASING - SIMONIZING
PHONE 9114                    MAIN & OAK
LINCOLNTON, N. C.

DELLINGER'S TEXACO STATION, EAST MAIN AND OAK STREETS, LINCOLNTON. Dellinger's Texaco Service Station was located at the intersection of East Main Street and Oak Street in Lincolnton. The style and flare of the time can be seen in the cars, attendant's clothing, and gas pumps. Dellinger's was a seller of Firestone tires and Exide batteries. Though many things have changed in Lincolnton since the 1950s, many people still remember these establishments. (Courtesy of Lincoln County Museum of History.)

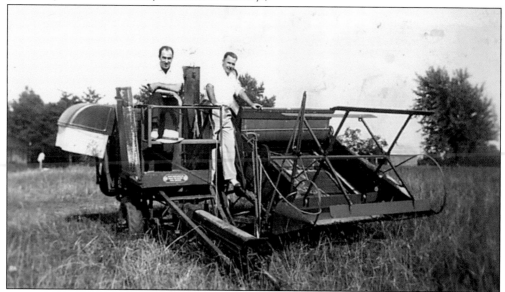

DEVON AND EARL ON COMBINE. Devon Boyles and Earl Boyles take a break from their work on one of Lincoln County's early combines for this photograph taken during the 1950s. (Courtesy of Corinne Boyles.)

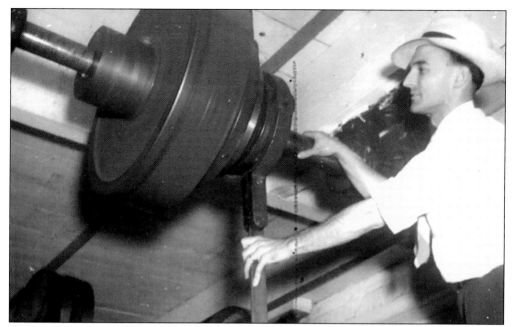

**C. Rhyne Little on Drive Shaft.** Clarence Rhyne Little, (1906–1999) son of Clarence S. and Lena Rhyne Little, checks a belt on a drive shaft in one of D.E. Rhyne's mills. He graduated from North Carolina State University with a degree in textiles and worked with Dan River Mills in Danville, Virginia, and Cortex Mills in Salisbury, before becoming superintendent in the Daniel Efird Rhyne Mills in Laboratory and Southside. (Courtesy of Edward Little.)

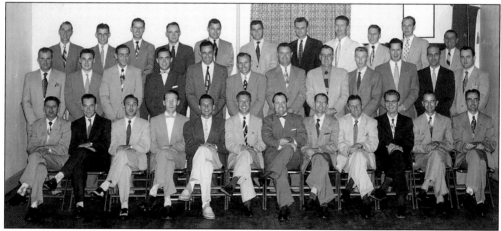

**Dale Carnegie Speech Class, Lincolnton.** Thirty-five businessmen from Lincoln County assembled at the North State Hotel in Lincolnton to learn speech techniques from a representative of the Dale Carnegie Institute. Those in attendance, from left to right, are (front row) Sam Harris, Glenn Ellis, unidentified, Richard Burris, Ed Ratchford, unidentified, instructor, Sidney Johnson, unidentified, Wally Keener, and two unidentified men; (middle row) unidentified, Don Rudisill, three unidentified people, Gordon "Shine" Goodson, unidentified, Elbert Combs, Ansel Bush, John Lockman, Joe Bondurant, and John Murphy; (back row) Tommy Bost, Robert Rudisill, Paul Mundy, Ralph Heavner, Asbury Howard, Herman Howard, unidentified, Paul Gabriel, Johnny Hoffman, Wayne Finger, and Ben Tillman. (Courtesy of Tom Howard.)

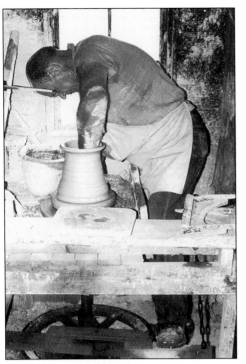

**BURLON B. CRAIG, NATIONALLY RECOGNIZED FOLK POTTER FROM LINCOLN COUNTY.** From Cat Square (Lincoln County), North Carolina, Burlon Bart Craig (1914–2002) is known throughout the country as the traditional folk potter. He was born in Lincoln County in 1914 and learned the pottery-making trade from traditional potters including Jim Lynn, Luther Seth Ritchie, Floyd Hilton, and Enoch and Harvey Reinhardt. Before World War II, he worked in a Hickory hosiery mill and served at a Wilmington shipyard during the war. After he returned from the war, he purchased the pottery kiln, house, and shop of Harvey Reinhardt and began turning again. He has received many local, statewide, and national awards for his work at preserving a time-honored practice. He is pictured here turning a pot at his treadle wheel. (Courtesy of Lincoln County Museum of History.)

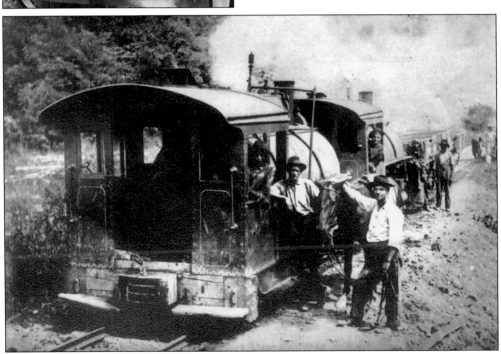

**A DAY ON THE RAILROAD.** This photograph, taken in 1908, shows a construction crew employed in extending railroad lines through the mountains of western North Carolina into Johnson City, Tennessee. Leaning against the engine is fireman Edward W. Mullen of Crouse. Holding the reins of his horse is construction supervisor John L. Troutman of Lincolnton. (Courtesy of Robert Dellinger.)

**LULA SEAGLE RHYNE AND HER COVERLETS.** A *Lincoln Times* newspaper article from 1959 claims "Progress has its place, but Mrs. Lula Seagle Rhyne prefers the 1700 era when it comes to weaving." Lula Seagle was born July 29, 1895, the daughter of John A. and Mary Catherine Mosteller Seagle. She learned the craft from her mother, who was well-known in the area for her coverlets. Lula specialized in coverlets and counterpanes, but also made place mats for dining tables, runners, rugs, and rag carpets. During the 1930s and 1940s, she sold pieces to Allanstand Cottage Industry in Asheville, wove for Gift Hong Shop of Summit, New Jersey, and wove for the old Tar Heel Shop of Charlotte. She was a member of the Southern Highland Craft Guild. She married Junius L. "Roy" Rhyne (1896–1962) in 1918, and they lived at Roy's grandfather's farm. She is shown in photograph to the right with two of her coverlets. (Courtesy of Barry Loug.)

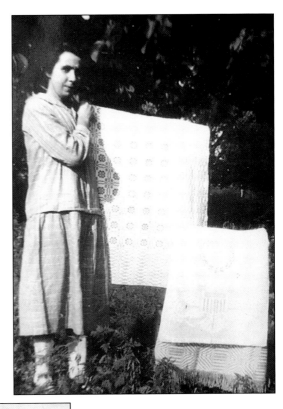

Kelly's Tea Room and Tourist Home
Franklin, North Carolina
"SCENIC CENTER OF THE SOUTHERN APPALACHIANS"

Nov. 16, 1940.

FRANKLIN

County seat of Macon County; 2,250 feet above sea level.

Accessible by U. S. Highways Nos. 19, 64, 23, 129; rail and bus connection.

Delightful year-round climate.

Headquarters for the half-million acre Nantahala National Forest.

150 Miles of hiking and bridle trails.

Camp grounds, picnic areas, swimming, boating, fishing, hunting, golfing, tennis.

Outstanding scenic attractions.

Cullasaja Gorge, Wayah Bald with its 55-foot rustic stone tower in the center of vast azalea beds, overlooks four states.

Dry Falls, Nantahala Gorge, Bridal Veil Falls.

Lumber, mining, hydroelectric power.

Dear Mrs. Reep:

I want two more sets of the blue luncheon sets, including napkins with the two center pieces 18 inches long, six mats to the set. I expect to go down to your place either the latter part of next week, or the first of the next, depending on the weather. I would also like one green set with four mats to the set.

Will pay you for the napkins when I come down.

Very truly,

Lassie Kelly,

Franklin, N. C.

**IN DEMAND.** In this letter from the C.C. and Ida Seagle Reep Papers at the Lincoln County Museum of History, Lassie Kelly from Kelly's Tea Room and Tourist Home in Franklin, North Carolina, requests "two more sets of the blue luncheon sets, including napkins with the two center pieces" from Mrs. Ida Seagle Reep (1893–1962). Kelly's Tea Room was just one of the locations that Mrs. Reep sold her coverlets, luncheon sets, and purses during the 1930s and 1940s. Laura Lou Copenhaver of "Colonial Coverlets" in Virginia was her best customer during this time period. Mrs. Copenhaver purchased products from Mrs. Reep to sell during festivals and bazaars all over the United States. Ida was the sister of Lula Seagle Rhyne, pictured above. (Courtesy of Lincoln County Museum of History.)

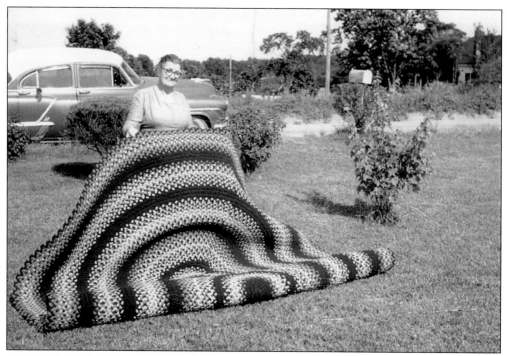

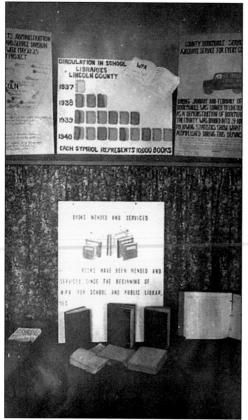

**IDA SEAGLE REEP.** Ida Seagle Reep was well known for her coverlets, table runners, place mats, and purses. She was also known for making braided rugs. She was a homemaker in western Lincoln County and was also very active in the Howard Creek Home Demonstration Club. She made the rug pictured above for her nephew Huitt Reep in the late 1950s. (Courtesy of Inez Reep Beam.)

**WORKS PROGRESS ADMINISTRATION (WPA) IN LINCOLN COUNTY.** Books and charts are displayed in an unidentified location for this photograph taken in 1940 by Elizabeth Mauney (Esterson). The display was part of National Activities Week that was celebrated from May 20 to 25, 1940. Elizabeth was in charge of the Lincoln County Library project. During this period, Lincoln County carried on six full-time WPA projects: Handicraft, Library, Commodity, Adult Education, Clerical, and Matron Service. The locations of the WPA projects were local schools, Carter Mill, Wampum Chapel, Lincoln County Courthouse, Excell Mill Office, and the Inverness Hotel. (Courtesy of Elizabeth M. Esterson.)

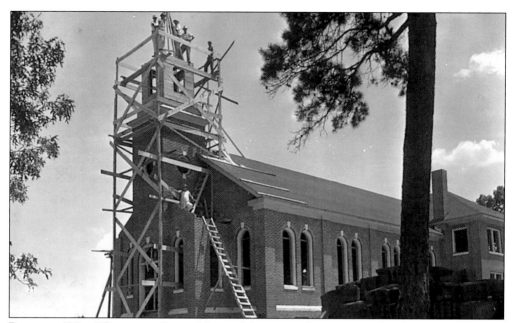

BUILDING "NEW" PLEASANT GROVE UNITED METHODIST CHURCH. For this photograph, builders stand atop Pleasant Grove United Methodist Church on wooden scaffolding. The congregation used the third church from 1895 to 1953. The present building, shown above, was dedicated in 1953.(Courtesy of Lincoln County Museum of History.)

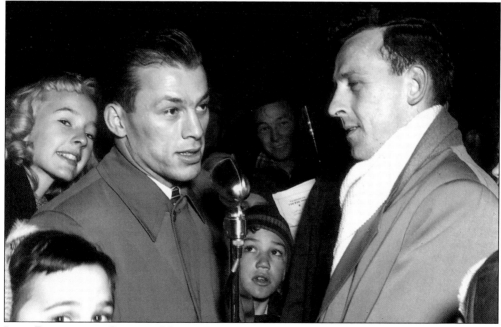

JACK BROWN AND CHARLIE "CHOO CHOO" JUSTICE. Jack Brown (1921–2001) was born in Gaston County. In the late 1940s, he started broadcasting from Lincolnton for a station in Gastonia. In 1953 he co-founded WLON and made it successful. He retired after 35 years. He is shown above interviewing UNC Chapel Hill football standout Charlie "Choo Choo" Justice after a football game in 1948. (Courtesy of Lincoln County Museum of History.)

**COWAN'S FORD PROJECT AND BRIDGE.** On September 28, 1959, construction began on the Cowan's Ford Dam Project in eastern Lincoln County. Duke Power's Construction Department built the dam on the site of the Revolutionary War battle of Cowan's Ford. The battle took place on February 1, 1781. The concrete and earth-filled dam stretches a mile long and spans the Catawba River from Mecklenburg County to Lincoln County, a distance of 5,649 feet. The dam measures 100 feet in height. It took three years to build and forms a body of water covering 33,000 acres, with a shoreline known as Lake Norman. With the completion of the project, the Cowans Ford Plant is among the largest privately-owned hydroelectric generating centers in the United States. (Courtesy of Odell S. Hager.)

**BRIDGE FROM TRIANGLE TO CORNELIUS.** The bridge connecting the route from Triangle to Cornelius was razed during the construction of the Cowan's Ford Dam Project in the late 1950s and early 1960s. The Cowan's Ford dam impounds the water of Lake Norman, named for retired Duke Power President Norman A. Cocke. (Courtesy of Odell S. Hager.)

**S.P. Houser Jewelry Store, Lincolnton.**
During the early years of the 20th century, Lincolnton boasted two banks, two railroad depots, two newspapers, boardinghouses and hotels, and a wide variety of businesses. One of the businesses in the downtown area was S.P. Houser Jewelry Store. In the shop pictured in this 1907 photograph, Silas P. Houser sold assorted timepieces and jewelry and offered repair service of these items. As shown from the exterior of the building, Mr. Houser made certain that his place of business was well marked. From advertisements appearing in the local newspaper, customers might select from "new patterns of jewelry," "a 16 size thin model Elgin watch for $5.00," or "one dollar alarm clock for 75 cents, guaranteed one year." (Courtesy of Regina Beam.)

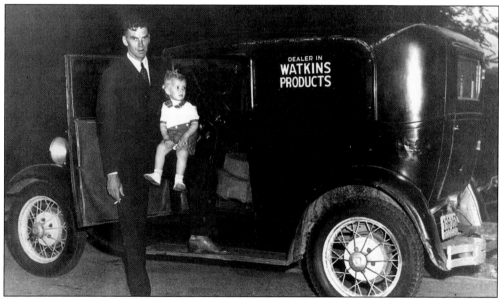

**"Doctor" Finger: Luther Voigt (Legs) Finger Sr.** Luther Voigt (Legs) Finger Sr. was a dealer in Watkins products in the late 1930s and early 1940s. He sold and delivered Watkins products to homes in Lincoln and Catawba Counties. The Depression and accompanying hard times led to his title of "doctor." He had concocted a medicine that he claimed would take corns off a person's feet. When he did not have a car available to sell and distribute Watkins products he would leave home early in the morning catching a ride to a country store where he would perform his services of removing corns. Shown with him in this 1944 photograph is his son, Luther Voigt Finger Jr. (Courtesy of Lincoln County Museum of History.)

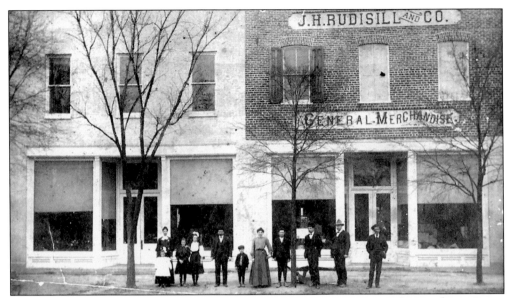

**J.H. Rudisill and Company, General Merchandise, Lincolnton.** The north-northwest corner of the Courtsquare was once described as the busiest corner in Lincolnton. This photograph was taken in the early 1920s when John H. Rudisill operated a general store at the corner of West Sycamore and North Aspen Streets. Among the numerous businesses that have been here are Robinson-Daniels, Modern Electric, Farmer's Cooperative Exchange (FCX), and Rogers Furniture Co. Keever Bicycle Shop, Chamber of Commerce offices, and the local telephone exchange are other activities that have been located here. The building is currently owned by Lincoln Lodge No. 137 A.F. & A.M. (Courtesy Lincoln County Museum of History.)

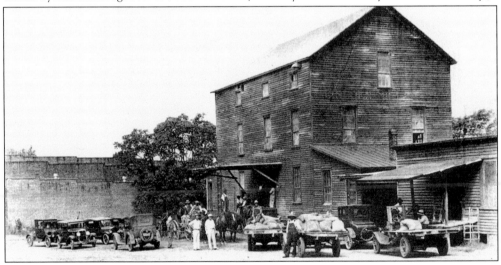

**Lincoln Milling, Company, Lincolnton.** The Lincoln Milling Company, located two blocks south of East Main Street along the railroad between South Cedar and South Poplar Streets, was one of the two important markets for Lincoln County wheat farmers. The mill bought grain, custom-ground flour for farm families, and made high-grade flour sold in stores. E.C. Baker owned the mill around World War I. Later owners were Robert Dellinger, S.K. Beal, B.J. Ramseur, and Heim Hoover. Following B.J. Ramseur's death, Paul Whisonant became the mill's sole owner and remained so until fire destroyed it. (Courtesy Lincoln County Museum of History.)

# Four

# MANY FACES OF
# LINCOLN COUNTY

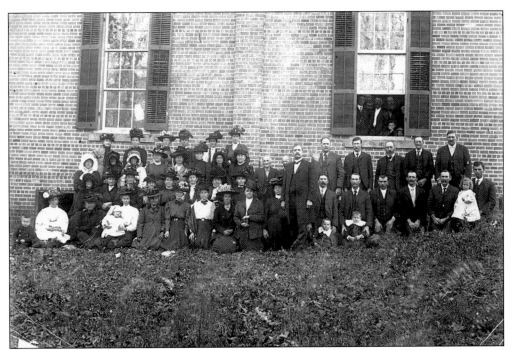

TRINITY CHURCH GROUP. A large group of distinguishingly dressed men and women assembled beside Trinity Lutheran Church in Vale, western Lincoln County, for this late 19th–century photograph. The congregation first worshiped in a building constructed of logs under the leadership of the first pastor, Rev. David Henkel. Featured in the photograph above is the brick building constructed for Trinity Church during the pastorate of Rev. M.L. Little (1876–1882). (Courtesy of Dr. James L. Haney.)

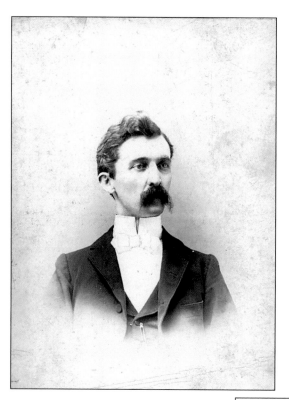

**Dr. Luther Lindsay Lohr.** Dr. L.L. Lohr (1862–1939) was born in Lincoln County and was a descendant of pioneer Valentine Lohr. He was a professor at the old Lutheran College in Dallas, where he later became president. He attended the Lutheran Theological seminaries in Gettysburg and Philadelphia, Pennsylvania. After completing his studies, he returned to Lincoln County and served as the pastor at Daniels Lutheran Church for 15 years. The North Carolina Lutheran Synod designated Dr. Lohr as the writer of the synod's history. He also published an article entitled *The German in North Carolina West of the Catawba* in the *Pennsylvania German* in 1911. (Courtesy Lincoln County Museum of History.)

**Alfred M. Yoder.** Alfred M. Yoder strikes a distinguished pose for this studio photograph taken during the late 1890s. Alfred Yoder was born in Lincoln County on April 25, 1869, the son of Daniel A. and Ellen Fulbright Yoder (1836–1874). He married Lucie LeSueur, and their children were Warren Alfred and Ruby Forrest. Alfred died on March 30, 1949. (Courtesy of Lincoln County Museum of History.)

**THE COLVARDS.** William (born 1823) and Sally Reeves (born 1825) Colvard pose for this early ambrotype during the late 1860s. The Colvards were the parents of Betty Colvard Gamble, wife of Preston Gamble. William and Sally Reeves Gamble are the great grandparents of Dr. John Gamble of Lincolnton. (Courtesy of John and Betty Gamble.)

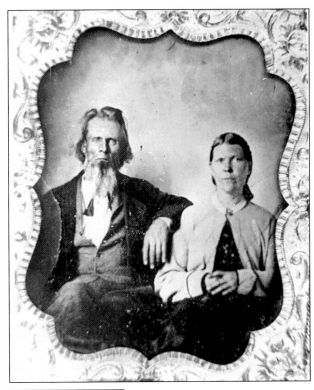

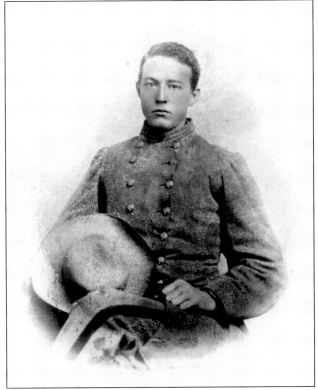

**EDWARD PHIFER, COMPANY K, 49TH REGIMENT, NORTH CAROLINA STATE TROOPS.** Edward Phifer (May 8, 1844– July 18, 1864) was the son John Fulenwider and Elizabeth Caroline Ramsour Phifer. He was a sergeant in Company K, 49th Regiment, NCST during the Civil War. He was wounded at the Battle of Petersburg in June 1864 and died in a hospital in Petersburg on July 18, 1864. Edwards tells of his joy at having his "likeness" taken in Petersburg during 1863 to send home to his mother. His body rests beside his brother William's at St. Luke's Episcopal Church Cemetery in Lincolnton and in the same area as his father and cousin Maj. Gen. Stephen Dodson Ramseur. (Courtesy of Lincoln County Museum of History.)

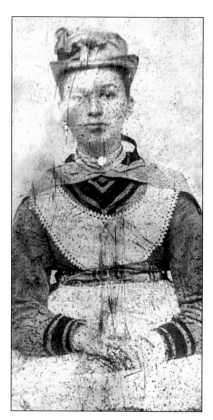

**"Aunt Martha" Sifford (Martha's Chapel).** Born October 25, 1855, Aunt Martha was the daughter of Sterling Womac and his first wife, Mary Ann Elizabeth Lawing Womac. Martha was about eight years old when her mother died in childbirth. While Martha's father fought in the Civil War, she and her younger sister, Mary, were cared for by families in the community in exchange for gifts of land deeded to them by Mr. Womac, who later remarried. Martha married Albert Franklin Sifford, and they had three children—Mary Lou Sifford (Hager), Lee Avery Sifford, and Rufus Elmer Sifford. Her husband, Albert, was the son of Aaron and Willie Pryor Sifford. When Aunt Martha died (September 9, 1907,) her body was taken to the cemetery then known as the Old Salem Graveyard for burial, and a terrible storm ensued. Due to the storm they were unable to bury Martha and her body was taken back home. It was several days before she could be laid to rest. It was reported that her husband, distraught at her passing, would sit by her grave and weep. One day, he said, she appeared to him in a vision and told him to build a church by the cemetery. Shortly, after he requested help from other men in the community, they built in 1908 the small white structure now known as Martha's Chapel. Martha's husband, Albert Franklin Sifford, lived another 12 years, passing away on June 16, 1920.

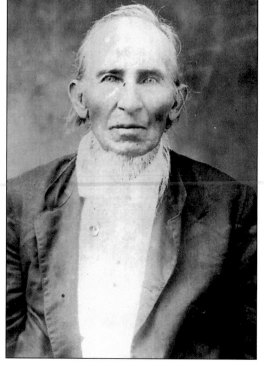

**Daniel Wacaster.** Daniel Wacaster (1820–1911) was born in Lincoln County, North Carolina, to George Washington Wacaster (1803–1886) and Margaret Reinhardt. Margaret died shortly after Daniel's birth in 1820. In the 1830s, part of this family moved to Spring Place, Georgia, where George Washington Wacaster served as the first sheriff of Murray County. (Courtesy of Bill Beam.)

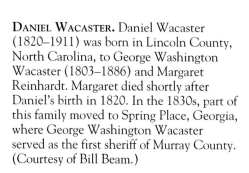

**WILLIAM "BILLIE" CONNOR CRYTZ.** William "Billie" Crytz was born in Lincoln County on January 3, 1834, to William and Barbara Dellinger Crytz. Prior the Civil War, he and his family moved to Cherokee County, Georgia. He returned to Lincoln County and enlisted as a volunteer in Company E "Shady Grove Rangers," 34th Regiment, North Carolina Infantry. Private Crytz was transferred to Company E, 12th Regiment, North Carolina Infantry while at Camp Gregg near Fredricksburg, Virginia. He was wounded during the campaign at Bristoe, Virginia, and admitted to General Hospital Number 9 near Richmond. He was captured on July 20, 1864, near Winchester and spent the remaining portion of the war at Camp Chase in Columbus, Ohio, until he was released on May 8, 1865. (Courtesy of B. Lee Howard.)

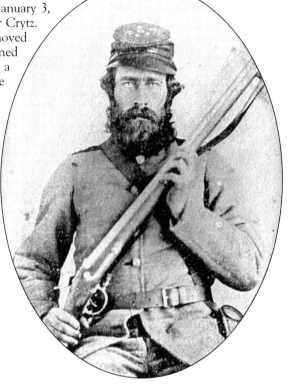

**JOHN ANDERSON ROBERTS (JULY 13, 1824–MAY 3, 1906).** J.A. Roberts, son of Joshua and Hester Moore Roberts, was born in Lincoln County. He was confirmed by Lutheran pastor P.O. Henkel on September 17, 1853. Like his father, John served his country through military service. He enlisted for service in the Mexican War in 1845, and on May 23, 1861, enlisted in the Confederate Army in Company B, 23rd North Carolina Regiment. He served as a fourth sergeant until August 1862. He married Mary Caroline Beam (March 22, 1827–June 30, 1871) on January 20, 1848, and after the death of Mary he married her sister Anna Beam Lyons. (Courtesy of Dr. James L. Haney.)

**REV. ROBERT ZENAS JOHNSTON.** Rev. Robert Zenas Johnston, the son of Robert D. Johnston (1803–1863) and Alice Graham, was born in Rowan County on December 14, 1834. He graduated from Davidson College in 1858 and from Columbia Theological Seminary in 1861. In 1861, he was licensed by the Concord Presbytery, ordained elder, and installed pastor of Providence and Sharon Church in Charlotte, Mecklenburg County, North Carolina. On May 15, 1861, he married Catherine Caldwell of Chester County, South Carolina. He came to Lincolnton's First Presbyterian Church in 1872, where he remained until his death on April 24, 1908. He also preached at Long Shoals, Iron Station, Stanley, Mount Holly, Dallas, and Shelby. (Courtesy of Lincoln County Museum of History.)

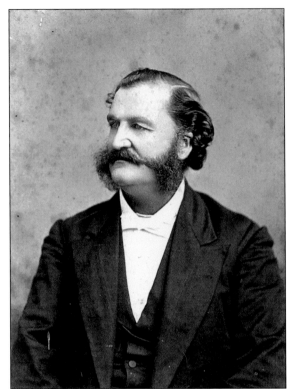

**REAR ADM. RUFUS ZENAS JOHNSTON, CONGRESSIONAL MEDAL OF HONOR RECIPIENT.** Rear Adm. Rufus Zenas Johnston was born in Lincolnton on June 7, 1874, to Rev. Robert Zenas Johnston and Catherine Caldwell Johnston. He received his early education in Lincolnton and graduated from the United States Naval Academy, Annapolis, Maryland, on June 7, 1895. He served as executive officer on the U.S.S. *New Hampshire* in the 1914 attack on Vera Cruz, Mexico. The admiral received the Congressional Medal of Honor for his extraordinary heroism at the occupation of Vera Cruz. Other awards and decorations that Admiral Johnston received include the gold medal for marksmanship from the Naval Academy, Battle of Santiago medal, Philippines Campaign medal, China Relief medal, Mexican Campaign medal, World War I medal with clasp, Navy Cross for convoy duty, letter of commendation from Secretary of War Baker and the Order of the Bust of Bolivar awarded in 1923 by Venezuela. Admiral Johnston died July 5, 1959, and is buried at Arlington National Cemetery. (Courtesy Lincoln County Museum of History.)

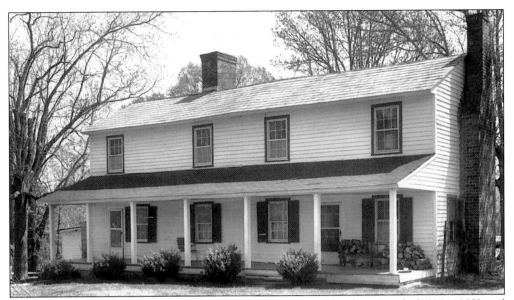

**SEAGLE RESIDENCE, REEPSVILLE.** This house was the home of Andrew Seagle (1828–1903) and his wife Annie Heavner (1831–1906). They built the house around 1860 on land they acquired in 1854 and 1857 from John Seagle, Andrew's father, and Maxwell Warlick. One of the house's chimneys bears the date 1860. This property is listed on the National Register of Historic Places and is distinguished from others in the county by the brick bake oven that stands at the south end of the house. (Courtesy North Carolina Office of Archives and History.)

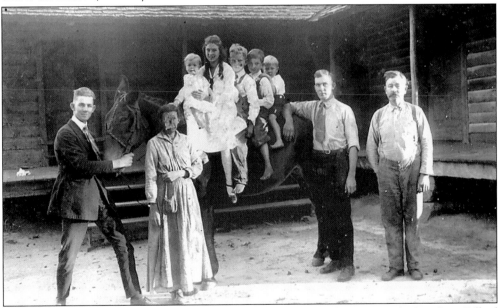

**ENOS AND MARY LOU SIFFORD HAGER FAMILY.** Members of the Enos and Mary Lou Sifford Hager family pose for a turn-of-the-century photograph taken at their home in eastern Lincoln County. The house was built after the Civil War on the farm that Aaron Sifford (1817–1897) bought in 1850. Members of the Sifford family, from left to right, are Bly Hager, Mary Lou Sifford Hager, Albert Franklin Hager, Louise Hager, Paul Hager, James Hager, Elmer Lee Hager, Dewey Hager, and Enos Hager. (Courtesy of Odell S. Hager.)

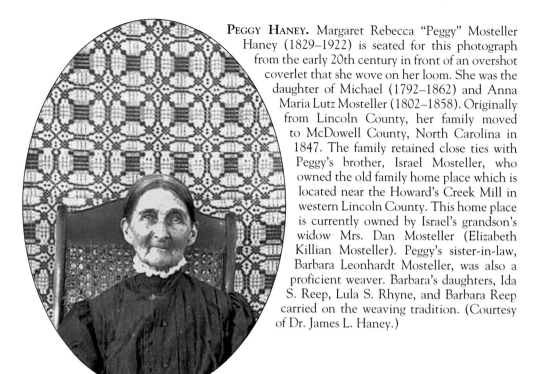

**PEGGY HANEY.** Margaret Rebecca "Peggy" Mosteller Haney (1829–1922) is seated for this photograph from the early 20th century in front of an overshot coverlet that she wove on her loom. She was the daughter of Michael (1792–1862) and Anna Maria Lutz Mosteller (1802–1858). Originally from Lincoln County, her family moved to McDowell County, North Carolina in 1847. The family retained close ties with Peggy's brother, Israel Mosteller, who owned the old family home place which is located near the Howard's Creek Mill in western Lincoln County. This home place is currently owned by Israel's grandson's widow Mrs. Dan Mosteller (Elizabeth Killian Mosteller). Peggy's sister-in-law, Barbara Leonhardt Mosteller, was also a proficient weaver. Barbara's daughters, Ida S. Reep, Lula S. Rhyne, and Barbara Reep carried on the weaving tradition. (Courtesy of Dr. James L. Haney.)

**HIRAM RHODES REVELS.** A North Carolina native born in 1822 to free parents, Hiram R. Revels was the first person of black ancestry to serve in the U.S. Congress. Revels resided in Lincolnton from 1838 to 1845. During this period, he operated a barber shop and sold candy, cakes, etc. in a small building behind the Motz hotel facing south Courtsquare. After leaving Lincolnton, he attended schools in Indiana, Ohio, and Illinois. He was ordained a minister in the African Methodist Episcopal Church. While residing in Natchez, Mississippi, he was elected to the Mississippi State Senate and for one year (1870–1871) served in the U.S. Senate, completing the unexpired term of Jefferson Davis, former president of the Confederacy. Thus he became the first person of black ancestry in either house of Congress. Revels was remembered in Lincolnton on November 13, 1989, when a historic marker was placed on the Courtsquare to mark his Lincolnton residency. (Courtesy of Lincoln County Museum of History.)

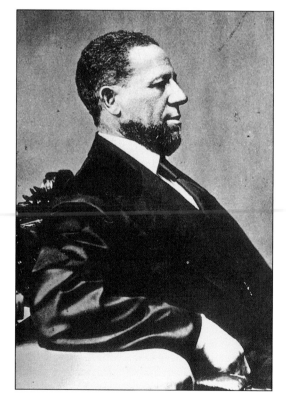

HON. HARLAN E. BOYLES. In 2000, the citizens of North Carolina saw the retirement of one of our state's most respected and trusted public officials. After a 46-year career managing the finances of the state, the Hon. Harlan E. Boyles passed the reigns of state treasurer to the Hon. Richard H. Moore. Born in 1929 to the late Curtis E. and Kate S. Boyles, Boyles attended North Brook in western Lincoln County before being stricken by polio and moving to the emergency hospital in Hickory. He completed the 10th grade while in Hickory through correspondence courses. He graduated from Crossnore High School in 1947 and earned a bachelor's degree in accounting from the University of North Carolina at Chapel Hill in 1951. In 1960 Boyles was appointed deputy treasurer under state treasurer Edwin Gill, a position he served for 16 years. In 1976, Boyles was elected state treasurer and served in this capacity for 24 years until his retirement. His tenure is marked by a Triple-A credit rating to the state, which saves millions in interest on bonds. Some of the honors awarded to Harlan E. Boyles include the following: Distinguished Public Service Award from the North Carolina Citizens for Business and Industry; the President's Award for the National Association of State Auditor's, Comptrollers and Treasurers; the Public Official of the Year Award from *Governing Magazine*; E.A. Morris Award as North Carolinian of the Year in 1994 from North Carolina Taxpayers United; and three honorary degrees. Appalachian State University's Walker College of Business honored Boyles in 1991 with the inauguration of a Distinguished CEO Lecture Series. In 2000, Boyles donated his personal papers and library to the Lincoln County Museum of History. Harlan E. Boyles passed away in 2003. (Courtesy of Lincoln County Museum of History.)

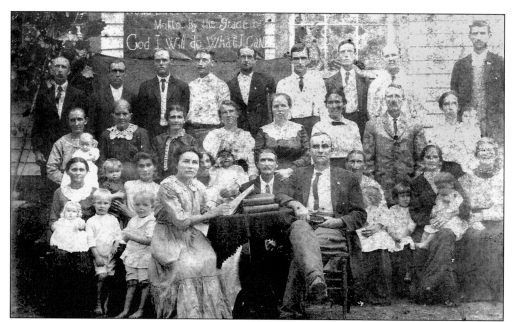

**HULLS GROVE BIBLE CLASS.** In the North Brook community in western Lincoln County, Hulls Grove Baptist Church was organized on September 11, 1897. M.F. Greenhill donated half and acre for the erection of a church building, which measured 30 feet by 40 feet. The church building cost $1,600. The Hulls Grove Bible Class poses for this photograph taken during the first decade of the 19th century. Their class motto was "By the grace of God I will do what I can." (Courtesy of Frances Crowell.)

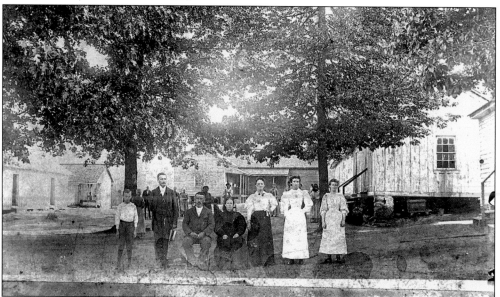

**COUNTY HOME.** Lincoln County's second "home for the aged and infirm" is shown in this photograph taken on April 10, 1896. The people, from left to right, are Lawrence Heavener, Charlie Heavner, Mr. and Mrs. Mark Heavener, Anna H. Robinson, Etta H. Warlick, and Tullie H. Hoyle. This county home was located on Highway 182 on Leonard's Fork Creek. (Courtesy of Lincoln County Museum of History.)

**CHARLESTON TRIO, JOE E. BONDURANT, NITA BEAL, AND MOSE STAMEY.** The members of the Charleston Trio were very active in the Lincolnton Little Theatre and musical and theatrical performances in Lincolnton during the 1950s and 1960s. Joe H. Bondurant played a double part in the Lincolnton drama *Thunder Over Carolina* in its two seasons, 1955 and 1956. He also had a double role in the Little Theatre's first period play *Lady Cotton*. Nita Beal, a talented tap dance winner, was a member of the acrobatic team at Lincolnton High School and modeled at Radio Center in Charlotte. Mose Steele Stamey played the role of "Fesso" in *Thunder Over Carolina*. He also played the role of "Ol John" in the first Little Theatre's *Lady Cotton*. (Courtesy of Lincoln County Museum of History.)

**PAGE AND RHODES (NURSES).** Wray Ramsey Page stands above Pearl Davidson Rhodes for this photograph taken in Lincolnton during the early 1920s. Pearl Davidson Rhodes was the superintendent of nurses at Lincoln Hospital until February 1923. The Lincoln Hospital offered a nursing school during the 1920s. The school was located across the street from the hospital on South Aspen Street near the home of Dr. Lester A. Crowell. (Courtesy of John and Betty Gamble.)

**JUDGE SHELDON M. ROPER.** Judge Sheldon M. "Shelley" Roper was born on March 16, 1901, in Greer, South Carolina, to Dr. John Caswell Roper, a Methodist minister, and Edith Bull Moseley. He graduated from the Citadel in 1922, where he excelled as a star athlete in football, swimming, and wrestling. He earned a degree in civil engineering from the Citadel and a law degree from the University of North Carolina at Chapel Hill. He came to Lincolnton in 1925 to practice law. He and Mary Hoyle of Lincoln County were married on September 25, 1925. A list of his positions in Lincoln County include the following: city attorney, solicitor of Lincoln County Court, judge of Lincoln County Court, and attorney for the Lincoln County School Board and First Federal Savings and Loan. He was a member of Lincolnton's First United Methodist Church, where he taught the men's Bible class and was a member of the board of trustees. From 1950 to 1954, Roper served as National Supreme Chancellor of the Knights of Pythias of the United States and Canada. (Courtesy of Shelley Roper Early and Carolyn Roper Lee.)

**KEMP BATTLE NIXON.** Kemp B. Nixon (1883–1964) was born in Lincolnton, North Carolina, on Sunday, August 12, 1883. He was the first son of Alfred and Iola J. Robinson Nixon. He graduated from the University of North Carolina at Chapel Hill in 1905 and attended old Trinity (Duke University) where he earned a law degree under the tutelage of Dean Mordecai. Upon graduating from Trinity in 1907, Kemp worked as a private secretary to Congressman E. Yates Webb. From 1908 until the time of his death, Kemp practiced law in Lincolnton. A list of his positions are as follows: trustee, UNC Chapel Hill; judge of recorder's court; superior court judge; county attorney; steward in the First Methodist Church; member of all Scottish and York Rite bodies and a member of the Shrine 100 Club; state senator, 1931–1935; chairman county board of education; and director and bank attorney of First National Bank. (Courtesy of Lincoln County Museum of History.)

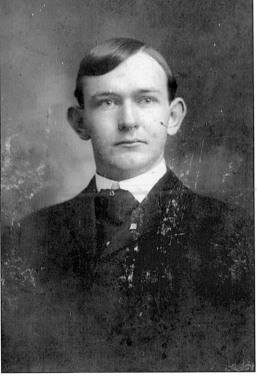

**COL. WARREN A. FAIR.** A native of Abbeville, South Carolina, Warren Adger Fair (1872–1947) came to Lincolnton to work as a newspaper reporter. He later became editor-publisher of the *Lincoln County News*. He was married in Lincolnton on June 2, 1891, to Irva Reinhardt, daughter of Wallace M. Reinhardt. W.A. Fair organized the Lincoln National Guard unit in 1912 and served with that unit on the Mexican border in 1916 and later in France. As a lieutenant colonel, he became the highest ranking officer from Lincoln County to serve in World War I. He also organized and was the first commander of the local VFW post. (Courtesy American Legion Post No. 30, Lincolnton.)

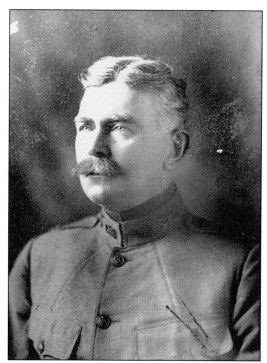

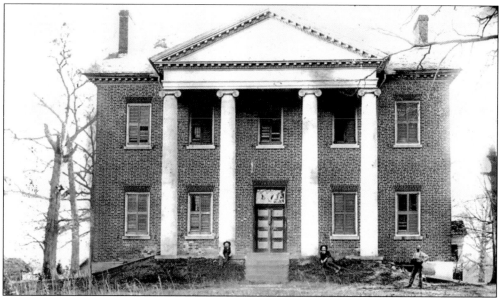

**INGLESIDE.** Four Ionic columns support the pedimented portico that stands as an impressive architectural feature in this photograph of "Ingleside," taken during the 1890s. Built about 1817 for Daniel Forney, this imposing Federal-style mansion reflects the wealth of Lincoln County families engaged in the early iron industry. Three unidentified men pose for photographer H.A. Siedell of Vaughan, Warren County, North Carolina. Seidell specialized in outdoor scenes using "flashlights," popular in 1890s photographs. His work covered areas along the Seaboard Airline Railway between Hamlet, North Carolina, and Lincolnton. (Courtesy of Lincoln County Museum of History.)

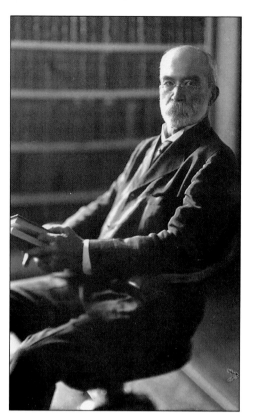

JUDGE WILLIAM ALEXANDER HOKE. W.A. Hoke was born in Lincolnton on October 21, 1851, to Col. John F. and Catherine Alexander Hoke. Hoke received his early education in Lincolnton at the Pleasant Retreat Academy under the tutelage of Prof. Hosea Hildreth Smith and Dr. William R. Wetmore. He attended Pearson's Law School, practiced law in Shelby for eight years, and returned to Lincolnton where he practiced with his father until 1888. He was a representative to the North Carolina Legislature from Lincoln County in 1889. Over his lifetime, positions he held included the following: judge of the superior court for the Lincoln district (1890–1905); justice of the North Carolina Supreme Court (1904–1924); and Chief Justice of the North Carolina Supreme Court (1924–1925). He married Mary McBee, daughter of Vardry A. McBee, on December 16, 1897. He became a member of the Society of Cincinnati on July 4, 1902. He was honored with the Degree of Laws from the University of North Carolina in 1909. He died on September 13, 1925. (Courtesy of Lincoln County Museum of History.)

JUDGE WILLIAM PRESTON BYNUM. Judge W.P. Bynum was born in Stokes County, North Carolina, on June 16, 1820. He was the son of Hampton (1783–1861) and Mary Coleman Martin (1785–1855). A graduate of Davidson College (August 4, 1842), he went on to learn the law profession under Judge R.M. Pearson. He married Anna Eliza Shipp, daughter of Lincoln County attorney Bartlett Shipp, on December 2, 1846. At the outbreak of the Civil War, he was elected lieutenant of the Beatties Ford Rifles. He was elected state solicitor of the Lincolnton District by the state legislature on December 12, 1862. He served as a delegate from Lincoln County at the Constitutional Convention of 1865 and was a representative to the state senate in 1865. He practiced law in Charlotte during the latter part of his life and died there on December 30, 1909. (Courtesy of Lincoln County Museum of History.)

**Col. John F. Hoke.** Col. J.F. Hoke was born in Lincolnton on May 30, 1820, the son of Col. John and Barbara Quickel Hoke. He graduated from the University of North Carolina at Chapel Hill and practiced law in Lincolnton and neighboring counties. He volunteered for service during the outbreak of the Mexican War in 1846 and was commissioned captain. Hoke served as state senator in 1850, 1852, and 1854, and he was a member of the house of commons in 1860 and 1865. In 1861, he resigned from his seat in the house to accept the office of adjutant general. He resigned this office when commissioned colonel by Gov. John W. Ellis. Hoke married Catherine Alexander, daughter of Col. William Julius Alexander, on October 30, 1850, and they had the following children: Judge William Alexander Hoke, Sallie Hoke Bader, and Nancy Childs Hoke. Colonel Hoke was the uncle of Maj. Gen. Robert F. Hoke. He died on October 27, 1888, while sitting on the front porch of his house watching a political procession move down Main Street in Lincolnton. (Courtesy of Lincoln County Museum of History.)

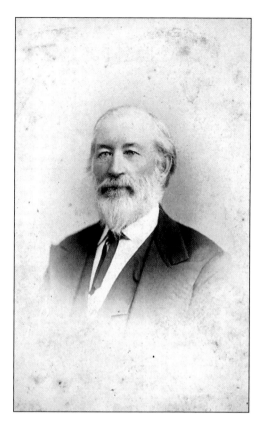

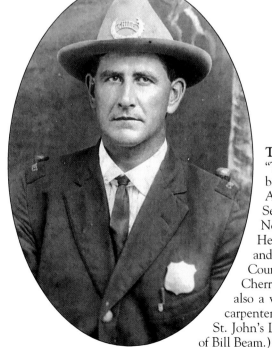

**Tom Seagle, Chief of Police.** Thomas "Tom" Francis Seagle (1879–1930) was born in Lincoln County. The son of John Adolphus (1855–1847) and Mary Catherine Seagle (1853–1941), he lived in rural Vale, North Carolina during the late 19th century. He first married Maude Stroupe (1887–1906) and then Lona Heavner. He served Gaston County as the Chief of Police for the Town of Cherryville during the early 20th century. He was also a very talented mechanic, home builder and carpenter. Tom and Maude Seagle were members of St. John's Lutheran Church in Cherryville. (Courtesy of Bill Beam.)

**BENJAMIN HUNT SUMNER.** Benjamin Hunt Sumner's image is captured in a daguerreotype from the 1850s. Sumner was born in 1827, the son of Benjamin (1801–1866) and Sarah Hunt Sumner. His family came to Lincoln County in 1844, as his father was hired to supervise the Pleasant Retreat Academy and Lincolnton Female Academy. Benjamin Hunt Sumner was postmaster from 1855 to 1865 and served on the Lincoln County Board of County Commissioners. He was a captain in the commissary department during the Civil War and was an active member of St. Luke's Episcopal Church in Lincolnton—where he and his wife are buried. He married Myra A. Ramsour, daughter of Jacob Ramsour, on June 8, 1852. Benjamin and Myra's children were Jacob Sumner, Charles McBee Sumner, Thomas Jethro Sumner, Mary Elizabeth Sumner Jenkins, and William Hoke Sumner. (Courtesy of Lincoln County Museum of History.)

**ZION METHODIST CHURCH.** A large group, possibly the entire congregation, from Zion Methodist Church stands outside the church with the large windows as a beautiful background for this photograph taken around 1916. This site was used by the church's congregation from 1837 to 1970, when it merged with Russell's Chapel and Bethel Church to form Messiah United Methodist Church. This building was razed in the 1970s, but the cemetery is still used. The site is located at the intersection of Flay and Shoals Roads in western Lincoln County. (Courtesy of Inez Reep Beam.)

**LINCOLN LODGE NO. 137, A.F. & A.M.** Lincoln Lodge No. 137, A.F. & A.M. assembled for its first meeting on June 20, 1851, with Alfred W. Burton serving as master. Members of Lincoln Lodge No. 137, A.F. & A.M. pose for this photograph taken by Clyde "Baby Ray" Cornwell in 1964. They are, from left to right, as follows: (first row) Glenn Beam, Risden Burris, Efird Burris, Vance Moss, Sam White, and Donald Houser; (back row) Milton Arrowood, Ken Mace, Joe Ross, and Bobby Baker. (Courtesy Lincoln County Museum of History.)

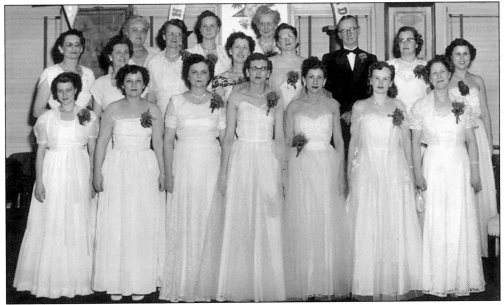

**ORDER OF THE EASTERN STAR OFFICERS, 1952–1953.** The Order of the Eastern Star is a fraternal organization centered on character-building lessons portrayed in its ritualistic work. Lincoln Chapter 114, Order of the Eastern Star received their charter in 1914. Members of the Order of the Eastern Star, Lincoln Chapter 114 and their offices are, from left to right, as follows: (front row) Helen Peeler, *Warden*; Pansy Digh, *Electa*; Beulah Rhyne, *Martha*; Farrie Blackburn, *Esther*; Ruth Grooms, *Ruth*; Sue Fortenberry, *Adah*; and Mildred Robinson, *Assoc. Conductress*; (middle row) Florence Lilly, *Assoc. Matron*; Mary Tobey, *Treasurer*; Fanny Bell Chapman, *Marshall*; Gladys Llewellyn; Mamie Wilson, *Worthy Matron*; Fred Hale, *Assoc. Patron*; Alzora Duncan, *Sentinel*; and Helen Combs, *Organist*; (back row) Fannie Hale, *Chaplain*; Ruth Ballard, *Conductress*; and Mattie Camp, *Secretary*. (Courtesy of Helen Peeler.)

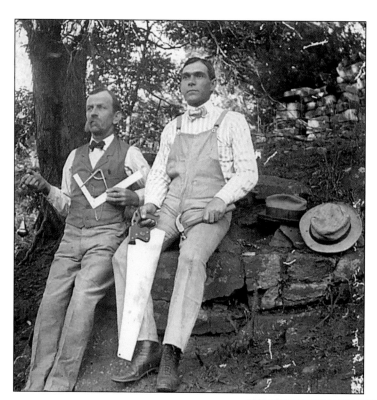

**DAD AND MR. WASH.** Labeled on the back "Dad and Mr. Wash 1897," this photograph from the Margretta Seagle Collection at the Lincoln County Museum of History shows William M. Seagle (1861–1948) on the left, and Mr. Wash with the working tools of masonry. William M. Seagle married Laura Minta Yoder (1866–1964) and was the father of Margretta Seagle. W.M. Seagle was a member of Lincoln Lodge No. 137, A.F. & A.M. (Courtesy of Lincoln County Museum of History.)

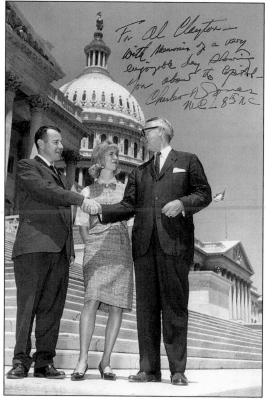

**ALTON CLAYTOR AND C.R. JONAS IN WASHINGTON.** Alton Bennett (1904–1980) and Mildred Claytor stand with Congressman Charles Raper Jonas on the steps of the nation's capital for this photograph taken during the 1950s. The note from Congressman Jonas reads, "For Al Claytor—With Memories of a very enjoyable day showing you about the capital, Charles R. Jonas, 8th NC." Alton B. Claytor served in the U.S. Army during World War II and was married to Mildred Perkins (1906–1995), a private piano teacher. Alton was a graduate of Davidson College, majoring in English and Latin. He went to work with his father-in-law, John Perkins, publisher of the *Lincoln Times*, and later took over as editor and publisher. (Courtesy of Lincoln County Museum of History.)

**SHERIFF JOSEPH H. KING.** Joseph King served as a delegate from Lincoln County to the Constitutional Convention of 1868. He was elected sheriff of Lincoln County in 1868 to fill the vacancy left by Sheriff Logan H. Lowrance. He served in this capacity until 1871, when he was defeated by John Alfred Robinson. He died of typhoid fever in July 1890. (Courtesy of Lincoln County Museum of History.)

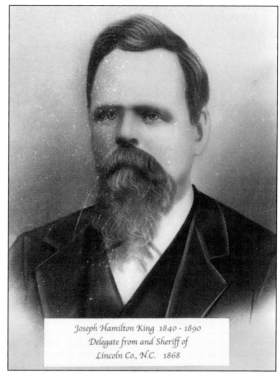

Joseph Hamilton King 1840 - 1890
Delegate from and Sheriff of
Lincoln Co., N.C. 1868

**WE ARE TRUE DEMOCRATS.** A donkey, "symbol of the Democratic party," is part of the Democratic Party's procession during a parade in Lincolnton. Joe Ross and Sheriff Frank Heavner flank a sign proclaiming "We Are True Democrats, We Vote a Straight Democratic Ticket." Visible in the background is the old McLean House on West Main Street in downtown Lincolnton. (Courtesy of Betty G. Ross.)

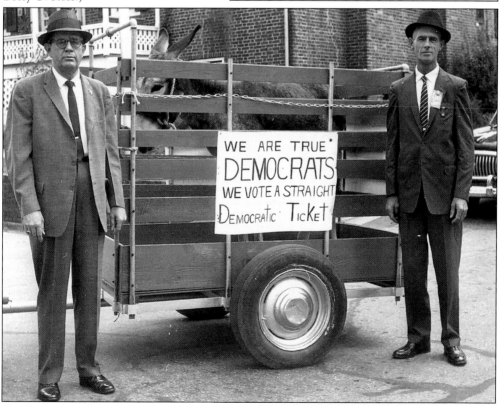

**CAPT. LEWIS ANTHONY.** Capt. Lewis Anthony, a native of Cherryville, was the first to fly from "Finger's bottoms," located behind the present Lincolnton Water Treatment Plant off Reepsville Road. Known as the area's first aviator, Anthony used this landing strip with and Johnny Jones from 1932 to 1936. Anthony had a passion for flying, which started at an early age. He developed this passion while watching local air shows (barnstormers). In 1942, he took a position with Pan American Airlines ferrying army bombers to Africa. He ended his career piloting cargo from Miami to South America. Captain Anthony retired in 1975 after 40 years of successful flying. (Courtesy of Susan and Nancy Anthony.)

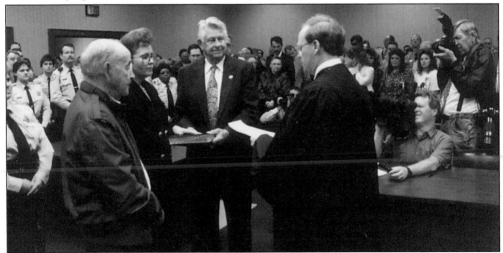

**SHERIFF BARBARA PICKENS.** Barbara A. Pickens, the first elected female sheriff in North Carolina history, was sworn in on December 5, 1994, as the sheriff of Lincoln County. She began her law enforcement career in 1971 as the first sworn female deputy in Lincoln County and became the first female chief deputy in 1984. She holds an A.A.S. in criminal justice from Gaston College and an advanced certificate from the North Carolina Sheriff's Commission. She is pictured above being sworn in beside long-time Sheriff Harven Crouse. (Courtesy of Barbara Pickens.)

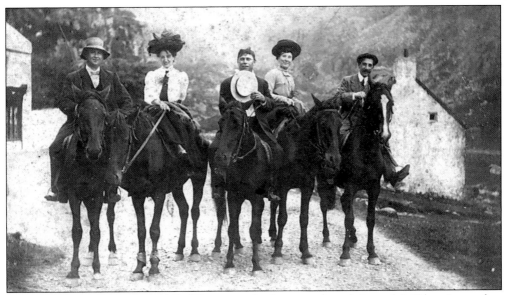

**EXCURSION TO ITALY.** Lemuel B. Wetmore, third person from left, and J. Edgar Love, first person from left, sit on their horses in Italy with two unidentified women and one unidentified man. Wetmore and Love took the European Tour No. 62 under the direction of Thos. Cook and Son of New York. They sailed from Montreal by the Allan Line Steamship *Sardinian* on Saturday, July 14, 1908. Others on their tour were from New York City; Lowell, Massachusetts; Charlotte, North Carolina; Columbus, Ohio; and St. Joseph, Missouri. (Courtesy of Lincoln County Museum of History.)

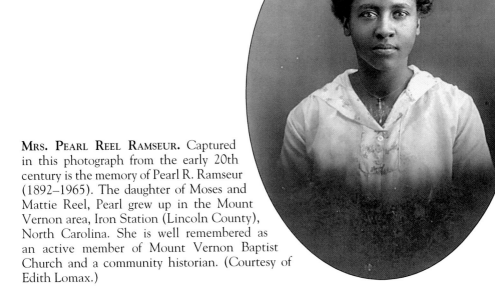

**MRS. PEARL REEL RAMSEUR.** Captured in this photograph from the early 20th century is the memory of Pearl R. Ramseur (1892–1965). The daughter of Moses and Mattie Reel, Pearl grew up in the Mount Vernon area, Iron Station (Lincoln County), North Carolina. She is well remembered as an active member of Mount Vernon Baptist Church and a community historian. (Courtesy of Edith Lomax.)

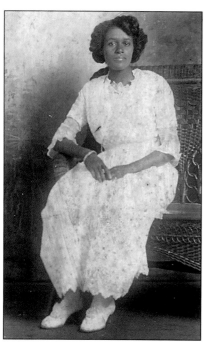

**Mrs. Odessa Lomax Johnson.** Seated on a wicker sofa and adorned in a beautiful, white dress, Odessa L. Johnson (1895–1955) poses for this early 20th–century studio photograph. Odessa was the daughter of Wellington and Fannie Link Lomax and the granddaughter of Bishop Thomas H. and Elizabeth Lomax. She grew up in Iron Station (Lincoln County), North Carolina. The wife of Robert Johnson Sr., she taught at Fancy Hill School in Gaston County and was a member of Links Chapel A.M.E. Zion Church in Iron Station. (Courtesy of Edith Lomax.)

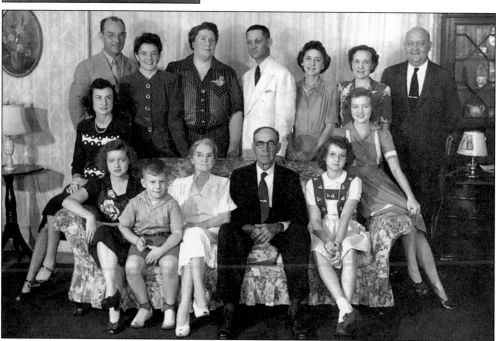

**Roper and Hoyle Family in Lincolnton, 1942.** Members of the Roper and Hoyle family chose the living room of the Hoyle family home at 226 West Main Street for this 1942 photograph. The family members are identified, from left to right, as follows: (seated) Frances Hoyle Broome, Carolyn Roper Lee, Guy Rudisill Jr., Georgia Miller Hoyle, Mark Hoyle, Rebecca Ramsaur Pennell, and Shelley Roper Early; (standing) Fithugh Hoyle, Elizabeth Hoyle Rudisill, Ethel Coffey Hoyle, "Bup" Ramsaur, Edna Hoyle Ramsey, Mary Hoyle Roper, and Judge Sheldon M. Roper. (Courtesy of Shelley R. Early and Carolyn R. Lee.)

**ERNEST RANDOLPH "CHUNK" SHIVES.** E.R. "Chunk" Shives hangs on to a passenger train for this 1911 photograph taken at the station in Lincolnton. This train station sat where Dr. R. Keith Dedmond's office stands at 301 South Academy Street. Chunk sold newspapers to passengers while the train sat at the station. He was born in Mecklenburg County, North Carolina, on May 1, 1901, and died in Lincolnton, North Carolina on January 24, 1979. (Courtesy of Ernest Randolph Shives Jr.)

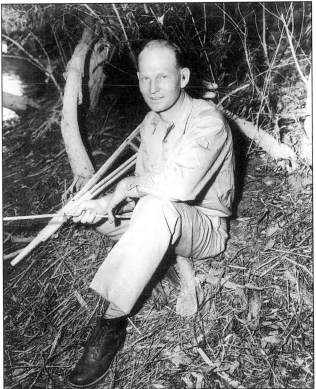

**PVT. PAUL C. HAGER, GERMAN PRISONER OF WAR, WORLD WAR II.** Paul Hager entered the service on April 18, 1942. He was first stationed at Fort Knox, Kentucky, and later sent to North Africa. He was wounded on February 14, 1943, when a shell hit his tank in North Africa. He was taken as a prisoner by the Germans, transported to Italy until the invasion, and then moved to Germany. He returned home from Germany in June 1944 aboard the *Gripsholm* with 63 other American soldiers. According to a newspaper clipping, "fishing ranked first on the list of things Private Paul C. Hager wanted to do when he returned home after some fifteen months as a prisoner of war in Germany." (Courtesy of Odell S. Hager.)

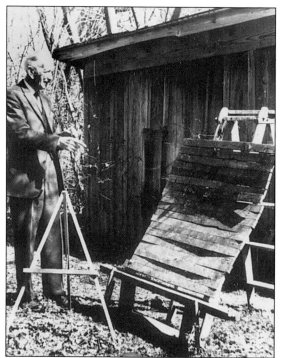

**Lemuel "Lem" Moore Nolen: Lincoln County's Folk Artist.** Lemuel M. Nolen (1884–1977) was born in Lincolnton, the youngest of nine children of Winslow Washington and Mary Ann Holland Nolen. In 1889, they moved to Crouse. He married Emma Beatrice Crouse in 1908. In 1917 William was born and Lem became a barber. In 1926, he opened the first beauty shop in Lincolnton, in the back room of Putnam's Barber Shop. In 1933, he opened Nolen's Beauty Parlor on Main Street. He retired at age 70, picked up some of his daughter Beth's art supplies, and began to paint. He painted in a primitive style from memories of childhood events and lifestyles of the past. He painted on anything from cardboard and wood to art canvases, using any type of paint from house paint to artist oils. He died on April 18, 1979, at age 92. (Courtesy of Helen Peeler.)

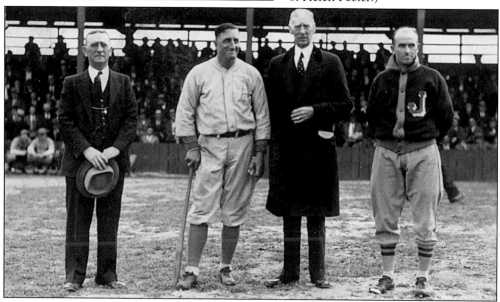

**Jay Shuford Boggs.** Jay Shuford Boggs picked up a baseball and bat for the first time at age six at Cherryville School. He was on the Cherryville team that won the Western North Carolina Championship at Chapel Hill in 1917. After serving one year in the U.S. Navy, he returned to the United States and enrolled at Lenoir-Rhyne College in Hickory, North Carolina, where he excelled in football, baseball, and basketball. After college he played Class "A" ball in the Sally League and had one year of professional baseball with the International League in Reading, Pennsylvania. He is the first man on the right and is shown with Connie Mack. After his baseball career, Jay Boggs resided in Lincoln County. (Courtesy of Polly Boggs Bryant.)

**COATSWORTH LEE GINGLES WILSON.**
Coatsworth Wilson (1841–1902)
was a scholar, Methodist Circuit
rider, building contractor, farmer,
and North Carolina legislator
from Lincoln County. He married
Margaret Susanna Huss (1840–
1907) on January 24, 1867. He
and his family lived near the old
Beam Lumber mill in Vale, western
Lincoln County, North Carolina.
After becoming upset with both the
Democratic and Republican Parties,
he promoted the Third Party
(People's Party) in Lincoln County.
(Courtesy of Helen Peeler.)

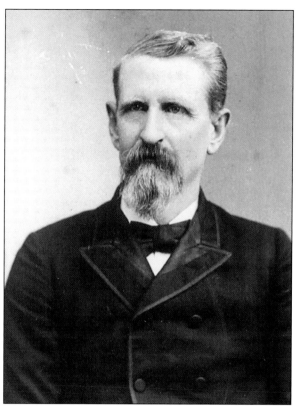

**"THE OLD HOME AT REEPSVILLE AT LAST."** A small humble frame house is shown on this postcard from the 1930s to say that you have made it to the welcoming section of Reepsville in western Lincoln County at last. (Courtesy of Ronnie Ward.)

**GLADYS MASON CHILDS.** Gladys Childs was a native of South Africa. After coming to Lincolnton, she worked as a columnist at the *Lincoln Times-News* and published a book called *People of Our Town*. She was active in the Lincolnton Little Theatre with the responsibility of the historical drama *Thunder Over Carolina* with Charles Loveland. She also worked as a judicial secretary in South Africa and Lincolnton. (Courtesy of Lincoln County Museum of History.)

**CAT SQUARE, WESTERN LINCOLN COUNTY.** Cat Square supposedly derived its name because people with too many cats discarded their extra animals at a western Lincoln County crossroads nearly a century ago. The area did not grow much over the years. It had 150 residents in 1993. The big day is the annual Saturday-before-Christmas parade. Main Street is the intersection of State Road 1113 and 1002. Shown in the photograph above is a chicken truck, which represents the area's tie to the poultry industry, the Cat Square Grand Ole Opry, and a country store. (Courtesy Lincoln County Museum of History.)

**CALDWELL NIXON "ON THE RUN."**
Caldwell Nixon (1909–1995) was a born runner and athlete. At age 73, he jogged 10 miles a day. In 1982, he was a member of Gov. Jim Hunt's Council on Physical Fitness, an eight-person group that promoted physical fitness on both the local and state levels. He was a mortgage banker who was inspired to take on a life lead by fitness when he took notice of how many of his colleagues were plagued with heart attacks and strokes. He was a member of the National Racquetball Association, the U.S. Jogging Association, the American Fitness and Running Association, the Denver (North Carolina) Run Club, the U.S. Men's Tennis Association, and the YMCA club in Charlotte. (Courtesy of Sallie Nixon.)

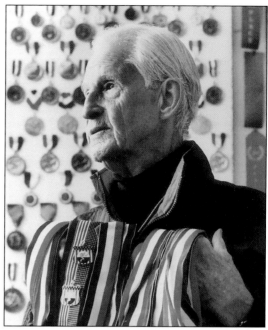

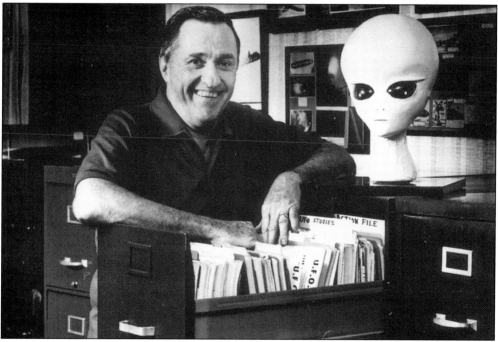

**GEORGE D'ESPARD FAWCETT, LINCOLN COUNTY'S UFO INVESTIGATOR.** George D. Fawcett was born in Mount Airy, North Carolina, in 1929 to a prominent banking family. He began investigating reports of UFOs (Unidentified Flying Objects) when he was only 14 years old. He founded several UFO study groups, including MUFON-NC, the Mutual UFO Network of North Carolina. Over the years, Fawcett has worked as a YMCA director, newspaperman, and textile worker. He has donated his collection of findings and reports to the UFO museum in Roswell, New Mexico. (Courtesy of Lincoln County Museum of History.)

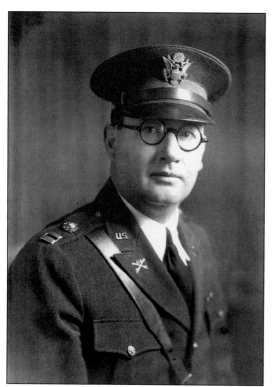

**GEN. WILEY MILLER PICKENS.** Gen. Wiley M. Pickens (1896–1980), a native of Spring City, Tennessee, served as superintendent of Lincolnton City Schools during the late 1920s and early 1930s. He worked as director of the North Carolina Veterans' Commission in Raleigh, North Carolina, from 1945 to 1947. He was the only man from Lincoln County to hold the rank of commander of the North Carolina American Legion. He was a veteran of World War I. Pickens was called to active duty with the Second Battalion, 105th Engineers unit of the National Guard where he commanded with the rank of captain. He later attained the rank of general. He was also a member of First United Methodist, where he served as a steward and assistant secretary of the church school. (Courtesy of Lincoln County Museum of History.)

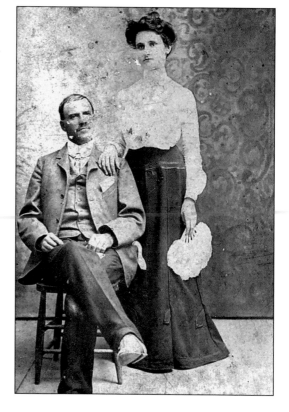

**THOMAS PEYTON "PATE" AND LAURA LEE BESS JENKS.** Thomas Peyton "Pate" (1861–1945) and wife Josephine Boyles Jenks (1884–1912) pose with an austere gaze for this late 19th–century studio photograph. Pate Jenks was a prosperous farmer in western Lincoln County. He owned a saw mill and a general store, and he was county magistrate during the 1910s. He built two elaborately detailed Victorian houses in Lincoln County. (Courtesy of Corinne Boyles.)

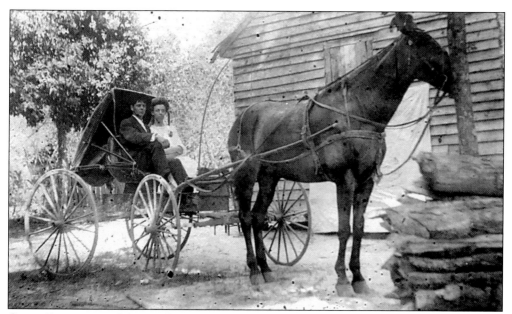

**OSCAR LUTHER AND MATTIE CRAFT BEAM.** Oscar and Mattie Beam relax in the carriage with their horse in the lead for this late 19th–century photograph. Oscar was the son of Squire Charles "Charley" Beam (1857–1928) and Susan Baxter Beam (1862–1947). Oscar lived at his father's house all his life. The house still stands on Highway 274 near Gaston County in an area then known as Lloyd Post Office (1885–1906). (Courtesy of John Robinson.)

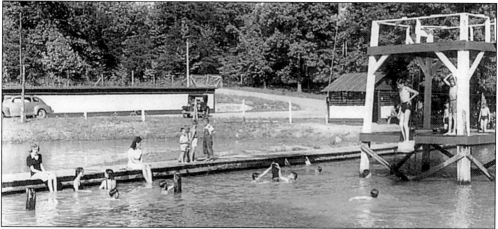

**LAKE SYLVIA, LINCOLNTON.** As the 1920s rolled in, there was little recreation in Lincolnton. Several facilities available at the time included a small pool and two bowling alleys located at the Lincoln Lithia Inn and two tennis courts at Fassifern—a girl's finishing school. Mr. Lawrence E. Rudisill, attorney and judge, actively took steps to build a swim park for adults and children. The piece of land Rudisill chose for his swim park was a natural depression with two strong springs in the center and a small branch entering from the east. This area is on the old Gastonia Highway, only 1.1 miles from the southern bounds of the Lincoln County Courtsquare. The old Gastonia Highway is now Laboratory Road. The exact location of the lake is now Vinewood Lane. The park opened around 1922 and was very successful. Lake Sylvia, named for Judge Rudisill's daughter Sylvia, lasted from 1922 until the beginning of World War II. (Courtesy of Paul Dellinger.)

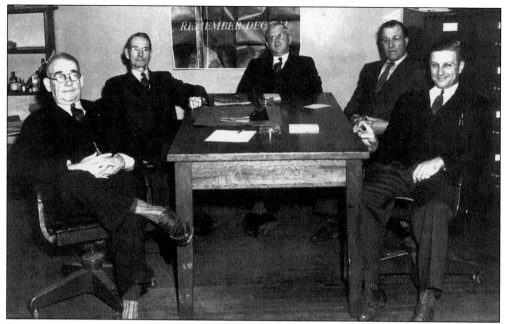

**BOARD OF ALDERMEN.** Lincolnton used the board of aldermen system for a number of years, until March 10, 1983, when the system was switched to the city council system (in use today.) The board of alderman at the beginning of World War II, pictured from left to right, are Frank Armstrong, Plato Miller, E.M. Brown, Heim Hoover, and Dave Warlick. The term "mayor" was first noted in 1899, with the term "intendent" used before that. (Courtesy of Lincoln County Museum of History.)

**"HE CAME TO DINNER, AND KEEPS DOING IT."** This was the headline in the local newspaper that described Lawrence Leatherman's frequent visits to family reunions and church homecomings. Shown here with chicken in one hand and corn and an apple in the other, Lawrence said that people made him feel so welcome that he could not resist attending various functions in a six-county area. He estimated his enrollment at about 25 functions each year. (Courtesy of Larry and Diane Leatherman.)

**"THE SHOE" AT WOODSIDE.** Visible from Highway 182 in Lincolnton is the large "shoe" at Woodside. Woodside is a Federal style plantation built around 1798 by Lawson Henderson. Among the Flemish bond bricks, Federal style mantels and wainscoting, and wooden ceiling medallions, is a large collection of furniture carved by Tilden J. Stone. Stone was the brother to Jessie Ramseur, past owner of the home. Stone and his nephew, Jack Ramseur, built the shoe for Susan Ramseur, Jack's daughter in 1945. The shoe still stands on the property and is a local landmark. (Courtesy of Lincoln County Museum of History.)

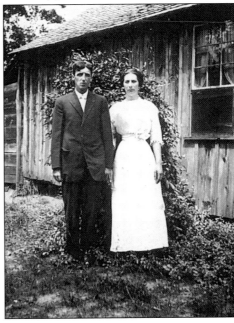

**THE CARPENTERS AT DANIELS.** Robert Clyde (1887–1935) and Rosa Emaline Seagle Carpenter stood outside a frame building at Daniels Lutheran Church around 1912. Robert was the son of John F. (1849–1926) and Rhoda Emaline Yoder Carpenter (1848–1928), and Rosa was the daughter of William M. and Laura Minta Yoder Seagle. Robert and Emaline were married in 1912. (Courtesy Lincoln County Museum of History.)

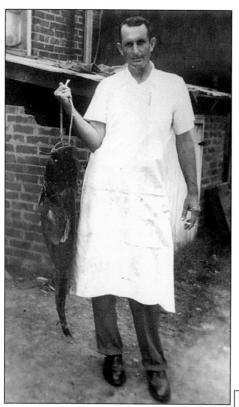

**"THE CATCH OF THE DAY."** Archie Baker holds the "catch of the day" in this photograph taken outside his store in Lincoln County during the 1960s. Baker's store was located near the Lincoln and Gaston County line, in the D.A. Kiser building. Baker ran his store from the 1940s to the 1980s. He died on February 22, 1993, and is buried at Salem Baptist Church. The catfish that Baker is holding in the photograph is believed to have come from Louisiana. (Courtesy of Alice Baker.)

**ELIZABETH SIMPSON SMITH.** Lincoln County author Elizabeth S. Smith (1923–1994) left her mark on literature. Thousands of copies of her books rest on school and library shelves across North Carolina and the rest of the nation. Ten of her books were published by prominent New York companies. She wrote many articles for magazine and newspapers about Lincoln County's history and its people. A list of her books include the following: *Breakthrough: Women in Aviation* (1981); *Breakthrough: Women in Law Enforcement* (1982); *Bear Bryant, Football's Winningest Coach* (1984); *Inventions That Changed Our Lives*, paper (1984); *Inventions That Changed Our Lives*, cloth (1985); *Five First Ladies* (1986); *A Dolphin Goes to School* (1986); *A Guide Dog Goes to School* (1987); *A Service Dog Goes to School* (1988); *Coming out Right*; and *The Story of Jacqueline Cochran* (1991). (Courtesy of Ed Smith.)

# *Five*

# EDUCATION AND SPORTS

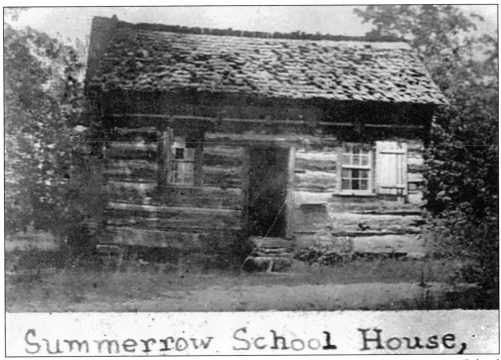

SUMMEROW SCHOOL HOUSE, LINCOLN COUNTY, NORTH CAROLINA. The Summerow School House stood as a testament to the strides made in Lincoln County during the mid and late 19th century to educate the children of the county. The one-room log schoolhouse accommodated a school class with one teacher. Students attended classes three to four months out of the year and worked on their family farms during the rest of the year. (Courtesy of Lincoln County Museum of History.)

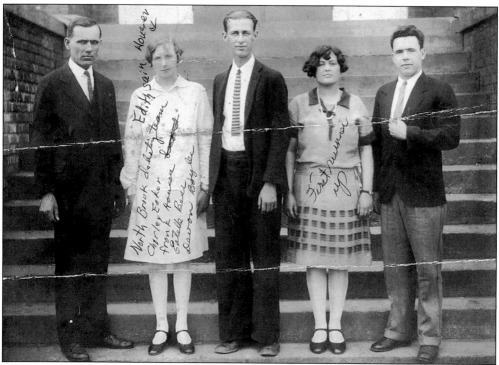

**NORTH BROOK HIGH SCHOOL'S DEBATING TEAM.** Charley Eaker stands with four members of North Brook High School's Debating Team for this photograph taken in front of the school in the 1930s. They are identified, from left to right, as Charley Eaker, teacher, Edith Sain Houser, Frank Houser, Estelle Bess (first runner-up), and Devon Boyles. (Courtesy of Corinne Boyles.)

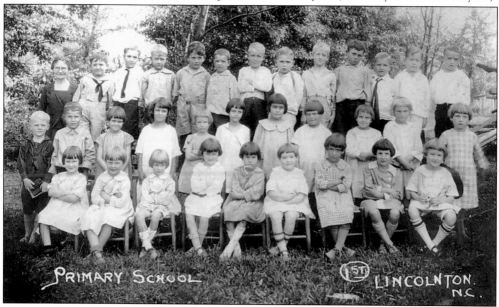

**PRIMARY SCHOOL, LINCOLNTON, NORTH CAROLINA.** A teacher from Lincolnton's Primary School pulled her students out of class for a class photograph during the 1920s. (Courtesy of Harvey and Celeste Jonas.)

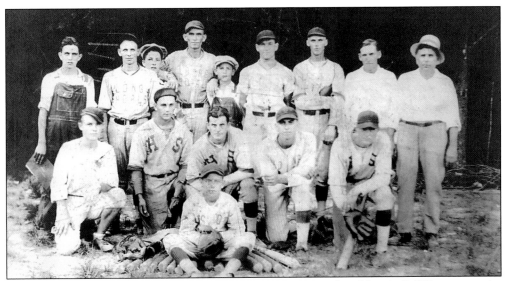

LONG SHOALS BASEBALL TEAM, LONG SHOALS. "You say you played baseball. Who was on the team? Just a bunch of us boys who lived around here. When did you play? 'Bout every Saturday evening in the summer time. Who did you play? Other teams like ours. Where did you play? In Mike's pasture. In the pasture. What did you use for bases? Rocks, mostly." This interview was conducted with Webb Carpenter around 1905 in Long Shoals. The Long Shoals baseball team wears their wool uniforms bearing their team name for this photograph taken during the 1910s. (Courtesy of Edgar Love III.)

TONY CLONINGER: LINCOLN COUNTY MAJOR LEAGUER. With roots in Iron Station (Lincoln County), North Carolina, Tony Cloninger grew up with baseball. After missing out on a trip that the Cherryville American Legion team took in 1953 to Miami for the American Legion World Series, he struck out 21 hitters in an American Legion game against Charlotte. He signed a $100,000 contract with the Milwaukee Braves in 1958. He learned a great deal about hitters, as he had a locker between Hank Aaron and Eddie Matthews. He was the Atlanta Braves's top winner in 1965, posting 24 victories. Bill Abernethy called Cloninger "the best pitcher the [Cherryville] Legion team ever had." Cloninger retired in 1972. (Courtesy of Lincoln County Museum of History.)

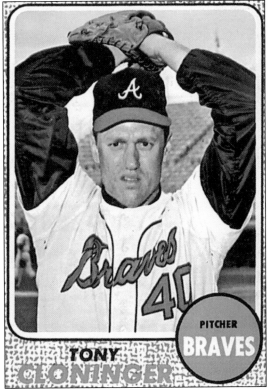

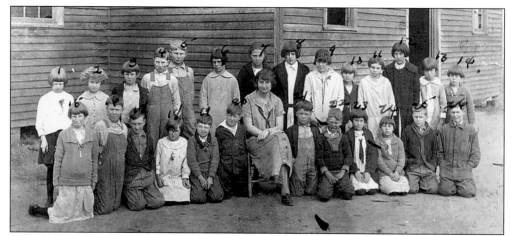

LOWESVILLE SCHOOL, 1924–1925. Third and fourth grade students at Lowesville School in Lowesville, (Lincoln County) North Carolina, take a break from their classwork to have their class photograph taken in 1924. The students, shown here from left to right, are as follows: (front row) Lucille Kelly, Yates Rogers, Lorrain Dellinger, Ruby Duckworth, Glenn Hager, Neal McIntosh, Roy Abernathy, Herron Grice, Elizabeth Robinson, Dorothy McConnell, Preston Henkle, and Irvin Duckworth; (back row) Marie Edwards, Lois Sifford, Addie Mae Kelly, James Hager, Paul Hager, Anna J. Abernathy, Margie Miller, Mary Helton, Virginia Rogers, Helen Duckworth, Mable Abernathy, Vida Helton, Edna Miller, and Ellen Jones. (Courtesy of Lincoln County Museum of History.)

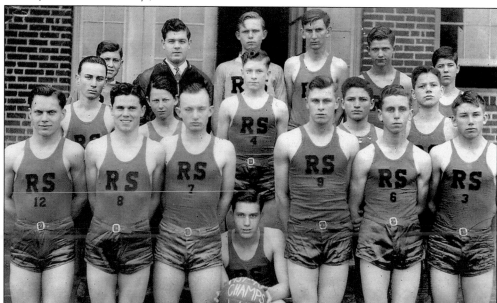

ROCK SPRINGS BASKETBALL TEAM, 1939–1940. Fred McCall Jr. holds a basketball that tells the story of Rock Springs High School's 1939–1940 season—"Champs, W.N.C." Team members include, from left to right, the following: (front row) Harry Graham, Rodney Sherrill, Grady Howard, Fred McCall Jr., Harven Crouse, Ab Lynch, and Olen Painter; (middle row) Kenneth Jetton, Harold Howard, Horace Crouse, J.W. Sigmon, and L.G. McCall; (back row) Bill Ballard, Coach Amendela, Howard Long, Hugh Duckworth, Aumon Sherrill, and Vaness Barker. (Courtesy of Lincoln County Museum of History.)

**BESS CHAPEL BASEBALL TEAM.** These ballplayers, from left to right, are (first row) unidentified, Willie Hull, and Ralph Hull; (second row) ? Heavner, unidentified, and Blanch Heavner; (third row) Floyd Beam and unidentified; (fourth row) unidentified, ? Brown, and Ray Beam. Willie Hull (1896–1973) was the son of Robert and Myra Eaker Hull of the North Brook community in western Lincoln County. He taught in the Lincoln County school system for 45 years and served as principal of North Brook #3 School for 30 years. He served on the Lincoln County School Board for eight years and was a member of the North Carolina Association of Educators. He was also a justice of the peace in Lincoln County for 20 years. Here, he sits in with his baseball compatriots from Bess Chapel Baseball Team in the 1920s. Willie Hull is credited with introducing sports and organizing many sports team in schools in western Lincoln County. (Courtesy of Lincoln County Museum of History.)

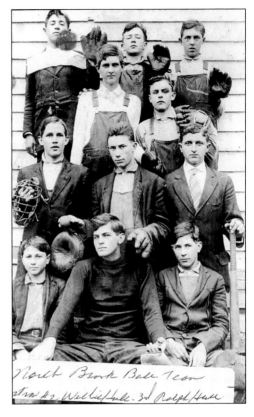

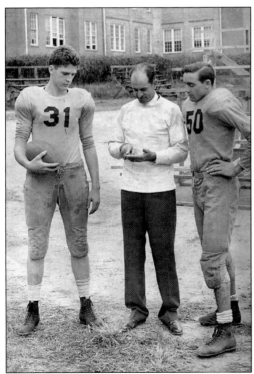

**COACH JACK KISER CALLS A MEETING.** On a cool day in October 1945, just after World War II, Coach Jack Kiser calls Charles C. Crowell (#31) and Jack L. Dellinger (#50) together for instructions. Coach Floyd David "Jack" Kiser (1906–1993) was an athlete at Lenoir-Rhyne College in Hickory—playing football, basketball, and baseball. He also served as student body president. He was named to the Lenoir-Rhyne College Sports Hall of Fame in 1979. After graduating in 1930, he became the coach at Cherryville High School. From 1943 to 1945, Kiser coached at Bessemer City High School. It was not until 1945 that he came to Lincolnton to be coach and principal of Lincolnton High School—a position he held until 1970. During the time he coached in Lincolnton, his teams captured 13 conference titles, 8 conference tournaments, and 2 state championships. His win-loss record for girls basketball was 236-15. (Courtesy of Jack L. Dellinger.)

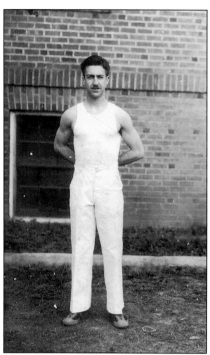

**JACK RAMSEUR, GYMNAST.** Jack Henry Ramseur (1911–1993) was a man of many talents. He is well-known in Lincoln County for his kindness, wit, energy, saw-playing, and wood carving abilities. He is shown in this photograph in his gymnast uniform while at Davidson College, where he graduated in 1931. He was an avid volunteer, serving with Christian Ministry of Lincoln County and the American Red Cross. He was an elder at First Presbyterian Church and received the Governor's Award for Outstanding Service in 1990. He carved the Lincoln County seal, which hangs in the county commissioners chambers, out of Honduran mahogany. (Courtesy of Sue Ramseur.)

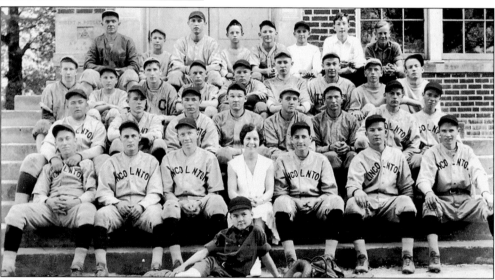

**LINCOLNTON HIGH SCHOOL BASEBALL TEAM, 1930.** Members of Lincolnton High School's Baseball team rest on the steps of the school for this 1930 photograph. The coaches and managers were C.D. "Block" Smith, coach; Beverly Costner, manager; and David Wilkinson, assistant manager. The players are listed as follows: Curtis Broome, John Rudisill, Willie Ramsey, John Broome, Alexander Proctor, Hunter Mauney, Kermit Cloninger, Kemp Huss, Elmore Goodson, Yates Ward, Elmer Beal, Fred Rudisill, Ruffin Self, Carl Fortenberry, and Loy D. Elmore. The team's substitutes were James Kale, Bill Kistler, Everett Mullen, Ralph Crenshaw, Charles Tilson, Johnny Lee, Edwin Russell, Merton Rudisill, Bill Mauney, James Little, Raymond Rudisill, Clyde Cornwell, James Cornwell, Charles Ramseur, Ralph Yoder, Russell Mincy, and Melvin Lingerfelt. (Courtesy of Lincoln County Museum of History.)

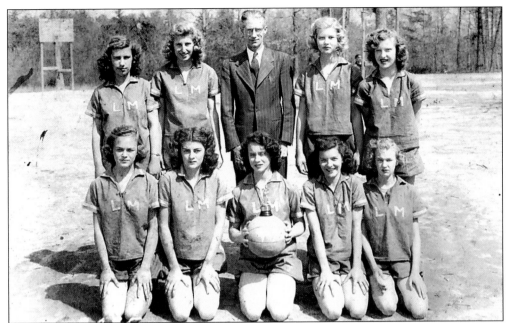

LOVE MEMORIAL SCHOOL'S GIRLS BASKETBALL TEAM. With the basketball court in the background, Principal Carl Ayers stands with his girls basketball team at Love Memorial School in Lincolnton during the late 1940s. (Courtesy of Lincoln County Museum of History.)

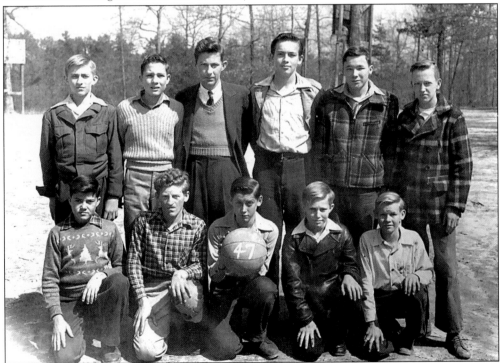

LOVE MEMORIAL SCHOOL'S BOYS BASKETBALL TEAM. An unidentified teacher wears his academic sweater and tie for this photograph taken during the late 1940s of the Love Memorial School's boys basketball team. (Courtesy of Lincoln County Museum of History.)

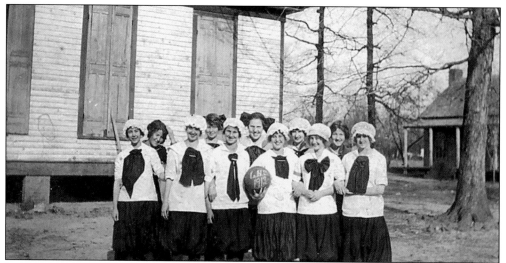

**LINCOLNTON HIGH SCHOOL'S 1913 GIRLS BASKETBALL TEAM.** Appropriately clad in the style of the period, the 1913 girls basketball team of Lincolnton High School stand for this photograph in Lincolnton. (Courtesy of Lincoln County Museum of History.)

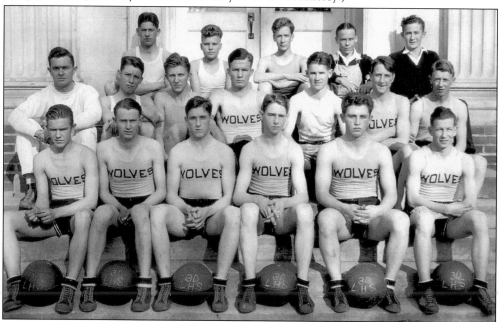

**"WOLVES" BASKETBALL TEAM, LINCOLNTON HIGH SCHOOL, 1930.** Lincolnton High School's Boys Basketball team members sport their "wolves" uniforms in the photograph from 1930. The coaches and managers were Charles D. "Block" Smith, head coach; Mug Mullen, assistant manager; and Ralph Crenshaw, manager. Buck Mauney and Willie Ramsey were the team's captains. The team members and their positions are as follows: Fred Rudisill, guard; Kermit Cloninger, guard; Willie Ramsey, guard; Buck Mauney, forward; L.D. Elmore, forward; Ralph Yoder, forward; and Frank Heavner, center. The substitutes and their positions are as follows: Kemp Huss, guard; Elmer Beal, guard; Robert Allison, guard; John Broome, forward; Jessie Robinson, forward; James Kale, forward; and Alexander Proctor, center. (Courtesy of Lincoln County Museum of History.)

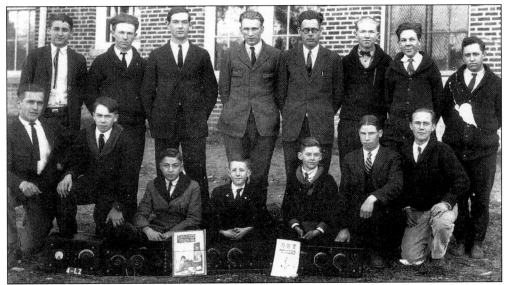

LINCOLNTON'S RADIO CLUB OF 1925. Radio was in its infancy when members of the local radio club were pictured, with the radio sets they built, in the 1925 Lincolnton High School annual *The Pine Burr*. William Yoder is said to have built the first radio in Lincolnton. Shown from left to right are (front row) Steve Dellinger, Charles Jetton, Melvin Karesh, Sanders Guignard, William Ridenhour, Forest Shuford, and Ralph Parker; (back row) two unidentified people, William Yoder, unidentified, W.M. Glenn, Loy Reep, Melza Roseman, and Victor Rudisill. The unidentified members were Austin Abernethy, William Carpenter, and Lawson Rhyne. Urias Pierce, also a member, was not present. (Courtesy of Lincoln County Museum of History.)

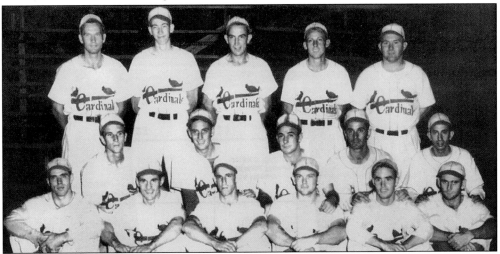

LINCOLNTON CARDINALS. At the end of World War II North Carolina had some 45 minor league baseball teams. The Lincolnton Cardinals, a popular team from 1947 through 1951 and a member of the Western Carolina League, was owned by D.H. "Buck" Mauney Jr. Other stockholders were Joe Ross and Joe Polhill. The 1948 team, both a pennant winner and playoff champions, are, from left to right (front row) Hal Abernethy, Chunk Rudisill, Junior Dodgin, Reid Campbell, Bobby Caldwell, and Judd Harmon; (middle row) Fred Withers, Ben Pollock, J.R. Lineberger, Warren Richards, and Frank Richards; (back row) Marvin Mauney, Ernie Ibach, Bus Huffstetler, Jim Dodgin, and Red Mincy. (Courtesy of Lincoln County Museum of History.)

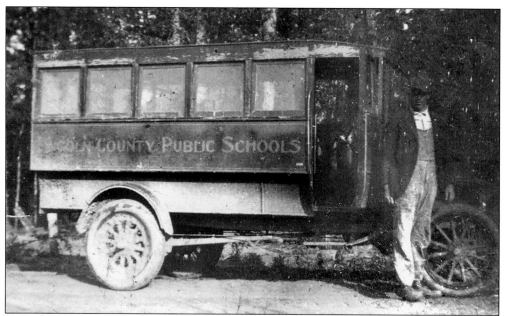

**LINCOLN COUNTY SCHOOL BUS.** Bussing children to school expanded public education to the most remote corners of the county—it reached those too far from school to walk. Luther Scronce stands beside one of Lincoln County's first school buses in this photograph taken around 1925. Fred C. Thompson was supervisor of school bus transportation in the county from 1932 to 1973. (Courtesy of Lincoln County Museum of History.)

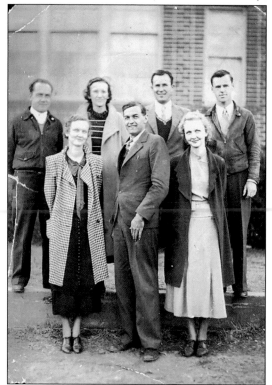

**PRINCIPAL WILLIE HULL AND HIS STAFF.** The staff at North Brook Number 3 School stands in front of the school building in western Lincoln County for this photograph taken around 1930. The members of the staff are, from left to right, as follows: (front row) Minnie Mull, Willie Hull (principal), and Juanita Mull; (back row) Carr Beam, Lois Willis, Luther Houser, and D.J. Beam. (Courtesy of Lincoln County Museum of History.)

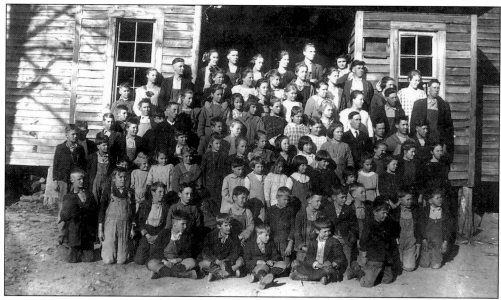

HEBRON SCHOOL GROUP. Hebron School began about 1865 one mile west of North Brook #3 School as a one-room log building erected on the lands of Solomon Young. A second school was erected around 1880, just a short distance from the first building. The building pictured above was constructed during the first decade of the 20th century, and in 1925 was consolidated with other small schools to make North Brook #3 School. (Courtesy of Corinne Boyles.)

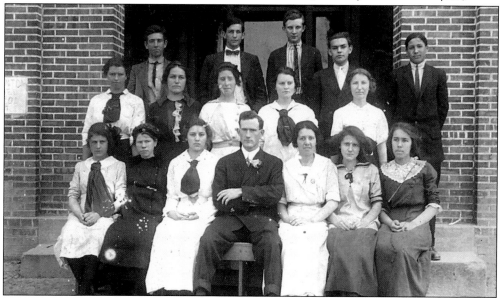

LINCOLNTON GRADED SCHOOL'S NINTH GRADE CLASS, 1913. Only six years after its construction, the Lincolnton Graded School provides a solid background for Professor James's ninth grade class of 1913. Members from left to right, are (front row) Inez Crowell, Marie Lineberger, Agnes Dellinger, Professor James, Connie Heavner, Flossie Rudisill, and Aura Heavner; (middle row) Myrtle Davis, May Crowell, Mabel Robinson, Annie Hoover, and Lillian Hoover; (back row) Richard Cornwell, Bruce Lander, John Robinson, John Mallard, and Paul Rhodes. (Courtesy of John and Betty Gamble.)

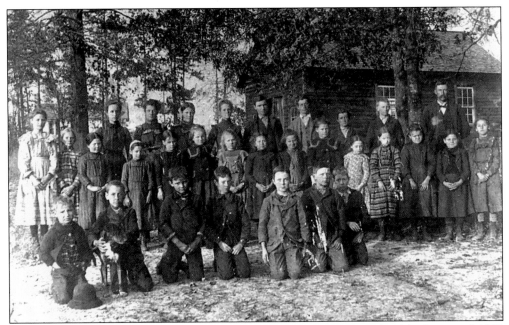

**BARNES SCHOOL GROUP.** The Barnes Schoolhouse was a one-room school built around 1890 at the southeast corner of what is today Lackey Road and Houser Farm Road. Pictured, from left to right, are (front row) Bub Beam, Charles Houser and dog, Clyde Beam, Clete Beam, and three unidentified persons; (second row) Maude Beam Jenks, unidentified, ? Brendel, seven unidentified persons, Lelia Jenks, Callie Davis, Lelia Barnes, unidentified, and Hattie Houser; (third row) Delia Houser, Cora Houser, unidentified, Katie Houser, Frank Beam, three unidentified persons, and Mr. Lutz, Teacher. (Courtesy of Helen Houser Killian.)

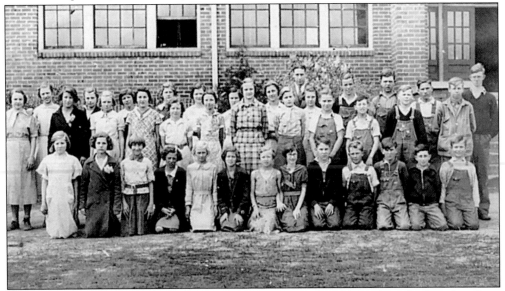

**CATAWBA SPRINGS SCHOOL GROUP, 1930s.** Sallie Lee Duckworth Luckey, third student from the left, and Hugh Duckworth, third student from the right, stand among their classmates at Catawba Spring Elementary School for this photograph taken during the 1930s. (Courtesy of Sallie Duckworth Luckey.)

**Triangle Baseball Team, c. 1918.**
During the early portion of the 20th century, before radio broadcasts brought major league games into homes, young men organized baseball teams in many small towns, mill villages, and rural communities across the United States to participate in "America's favorite pastime." In this photograph from around 1918, the Triangle baseball team is clad in wool uniforms with high stockings and equipped with mitts and bats. Featured, from left to right, are (first row) Dallas Barker and Marian Proctor; (second row) Harvey Cherry, Joe Cherry, Robert Nixon, and Rozzelle Proctor; (third row) Joe Graham, Etheridge Cherry, and Fred Long. (Courtesy of Mary Long Abernathy.)

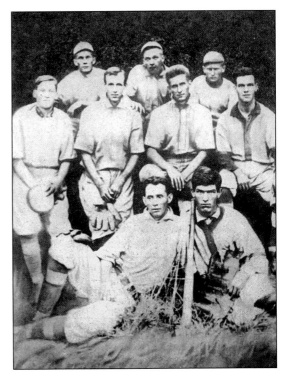

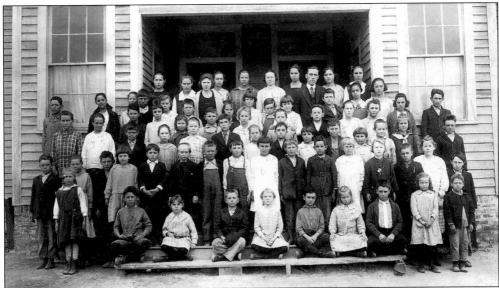

**Hickory Grove School Group, 1922.** The students at Hickory Grove School assembled on the steps of the school for this photograph taken in 1922. Some of the members of the class are identified as follows: Lucy Schrum, Connie Harrill, Margaret Auton, Nellie Auton, Ezma Grigg, James Setzer, Louise Litte, Archie Cauble, Mary Turner, Bess Shrum, Bill Cauble, Fusia Turner, Gertrude Setzer, Edith Lemmond, Mary Jane Keever, Fern Hoffman, Louise Cauble, Jessie Mae Setzer, H.C. Harrill, J. Lee Hoffman, Ethel Grigg, Jenny Turner, Everett Mullen, T.B. Auton, Kathleen Mullen, Mae Shrum, Irene Shuford, and Richard U. Shuford. (Courtesy of Leonard and Barbara Blanton.)

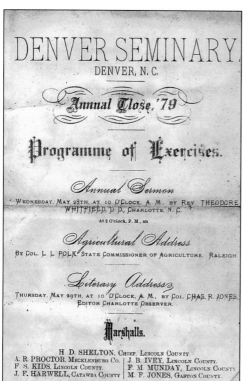

**DENVER SEMINARY'S PROGRAM OF EXERCISES, 1879.** Style and class are added to the text of Denver Seminary's Program of Exercises for the Annual Close of 1879. Denver Seminary was opened in Denver (first established as Dry Pond), North Carolina, during the early 1870s. Prof. D. Matt Thompson was one of the earliest instructors at the seminary. The annual close took place on Wednesday, May 28, 1879, at 8:00 am, and featured a sermon by Rev. Theodore Whitfield, D.D. of Charlotte. Col. L.L. Polk, state commissioner of agriculture, delivered an agricultural address, and a literary address was given by Col. Charles R. Jones, editor of the *Charlotte Observer*. (Courtesy of Lincoln County Museum of History.)

**CHARLES D. "BLOCK" SMITH.** Coach Charles "Block" Smith (1901–1944) taught and coached at Lincolnton High School. Shown here on the right, he served the school from 1925 to 1937. (Courtesy of Lincoln County Museum of History.)

CANON AT ACADEMY STREET SCHOOL, LINCOLNTON. Situated on the front lawn of the former Academy Street School is a canon believed to have been used during the Civil War. The school was originally named Maj. Gen. Robert F. Hoke School. The canon was reportedly removed from the site during World War II for the scrap drive. (Courtesy of Lincoln County Museum of History.)

HELEN PEELER'S SEVENTH GRADE HOMEROOM CLASS AT LINCOLNTON GRAMMAR SCHOOL, 1959. Members of the homeroom class are, from left to right, as follows: (first row) Larry Sain, Rusty Rhyne, David Bynum, David Leonard, Chip Stroup, Ray Crouse, and John Weaver; (second row) Betsy Heavner, Rita Summey, Judy Ewing, Becky Wright, Janice Sanford, Linda Huss, Paulette Stroup, and Jane Ward; (third row) Mary Edith Cody, Cynthia Campbell, Jimmy Love, Judith Lloyd, Libby Keever, Jane Cornwell, Carole Burris, Sheila Bondurant, and Patricia Allen; (fourth row) Todd Crowell, Tommy Hyder, Diane Honeycutt, Dennis Byrd, Yvonne Javert, Pam Beck, Judy Kay Bivens, Carol Long, Bill Morris, and Barry Lewis; (fifth row) Ernest Baxter, Alex Burgin, Michael Bumbarger, Bobby Turner, Steve Warren, Bill Shuford, and David Thompson. (Courtesy of Helen Peeler.)

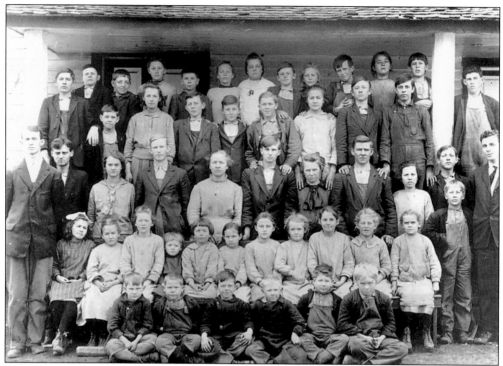

**TRINITY SCHOOL GROUP, C. 1917.** The classes at Trinity School, located near Trinity Lutheran Church in Cat Sqaure, line up for this photograph taken in 1917. (Courtesy of Dr. James L. Haney.)

**ASBURY ELEMENTARY SCHOOL'S SECOND GRADE CLASS.** A second grade class at Asbury Elementary School in Lincolnton dressed up in homemade Native American outfits for this class photograph during the 1950s. Margretta Seagle, supervisor of Lincoln County Schools, took the photograph. (Courtesy Lincoln County Museum of History.)

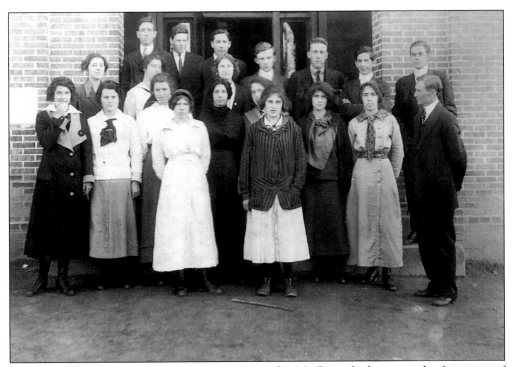

**LINCOLN HIGH SCHOOL GRADUATING CLASS.** Prof. M.S. Beam looks across the front row of students with an austere gaze for this photograph taken around 1916. The members of the graduating class are identified, in no particular order, as follows: Arnold Cochrane, Richard Cornwell, Inez Crowell, Mary Crowell, Myrtle Davis, Agnes Dellinger, Connie Heavner, Aura Heavner, "Weta" Hinson, Annie Hoover, Lillian Hoover, Bruce Lander, Marie Lineberger, John Mallard, Paul Rhodes, Mabel Robinson, John Robinson, Flossie Rudisill, and Richard Shuford. (Courtesy of John and Betty Gamble.)

**LIGHTS, CAMERA, ACTION.** The curtain is drawn and this unidentified group of actors, thought to be from Union High School, strikes many poses for this photograph taken during the 1930s. (Courtesy of Dr. James L. Haney.)

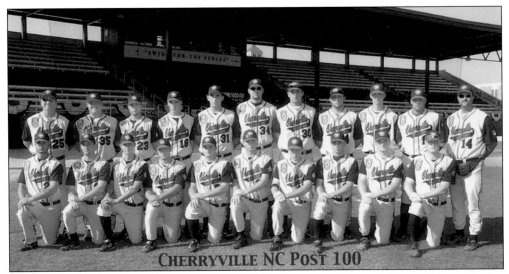

**CHERRYVILLE NORTH CAROLINA POST 100, 2003 AMERICAN LEGION WORLD SERIES.** During the 2003 season, the Cherryville North Carolina Post 100 reached the American Legion World Series in Bartlesville, Oklahoma. Members of the Cherryville Legion team are identified, from left to right, as follows: (front row) Ben Lastra, Chris Halubka, Josh McSwain, Josh Glover, Jonathan Walker, Chris Mason, Evan Wise, Jay Heafner, David Wise, and Matt Craig; (back row) Bobby Dale Reynolds (head coach), Travis Walls, Shane Summers, Steven Justice, Brock Alexander, Chuck Walker (assistant coach), Chris Cook, Jackson Beam, Wayne McDonald, Brandon Hurt, and A.J. Henley (assistant coach). Brandon Hurt and Evan Wise are from Lincolnton High School, and Jay Heafner, Chris Halubka, David Wise, and Matt Craig are from West Lincoln High School. (Courtesy of Don Wise.)

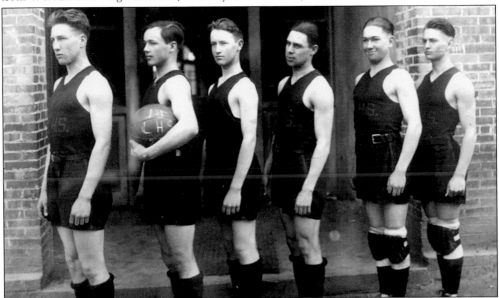

**LINCOLNTON HIGH SCHOOL BASKETBALL TEAM, 1921–1922.** Hugh Jenkins hugs a basketball that bears the writing: "1st LHS." Members of the team are identified, from left to right, as follows: Graydon Shuford, Hugh Jenkins, Howell Gabriel, Lemuel Wetmore, Edgar Love, and Sidney McCutcheon. (Courtesy Lincoln County Museum of History.)

# SOURCES

Brown, Marvin A. and York, Maurice C. *Our Enduring Past: A Survey of 235 Years of Life and Architecture in Lincoln County, North Carolina.* 1986. Reprint. Lincolnton, N.C.: Lincoln County Historic Properties Commission, 1987.

Industrial Locating Data, Lincoln County North Carolina 1959–1960. 1959. Raleigh, N.C.: Lincolnton Industry Commission, Lincolnton Chamber of Commerce and N.C. Department of Conservation and Development.

Haney Jr., James Lawton. *Stumbling Toward Zion: A Mosteller Chronicle.* 1998. Reprint. Moorhead, M.N: Sorbie Tower Press, 1991.

Lincoln County Historical Association. *Lincoln County Heritage,1997.* Waynesville, N.C.: Walsworth Publishing Company, Lincoln County Heritage Book Committee.

National Register of Historic Places Nomination, South Aspen Street Historic District. Survey and Planning Branch, North Carolina Department of Archives and History, Raleigh.

Peeler, Helen Wise. *Solomon Hoover and Descendants.* 1998. Lincolnton. N.C.

———*The Descendants of Peter Houser.* 1980. Lincolnton, N.C.

———*Frederick Wise and Descendants.* 1991. Lincolnton, N.C.

Sherrill, William L. *Annals of Lincoln County, North Carolina.* 1937. Reprint. Baltimore, Md.: Regional Publishing Company, 1972.

Philbeck, Madge W. *The Wood Family in Lincoln County, North Carolina.* 1992. Franklin, N.C.: Genealogy Publishing Service.

Zug, III, Charles G. *Turners and Burners: The Folk Potters of North Carolina.* 1986. Chapel Hill, N.C.: The University of North Carolina Press.

MANUSCRIPT COLLECTIONS
Lincoln County Museum of History, Lincolnton, North Carolina
  Willie A. Hull Papers.
  Margretta Seagle Collection.
  Lander and Wetmore Family Papers.
  Wiley M. Pickens Collection.
  William H. Sumner Collection.
Lincoln County Public Library, Lincolnton, North Carolina
  Lohr Family, vertical file.
  Ramsour Family, vertical file.
  Cloninger Family, vertical file.
  Scrapbook, Lincoln County Library.
  Early Education (Schools), vertical file.

# INDEX